English Ceramics

Marcus and Cas

A small reminder of Rode

Richard.

10 July 2006

English Ceramics

Two Hundred and Fifty Years of Collecting at Rode

Julie McKeown

Rode Hall
in conjunction with
Philip Wilson Publishers

First published in 2006 by
Philip Wilson Publishers
109 Drysdale Street
The Timber Yard
London N1 6ND

Distributed throughout the world
(excluding North America) by
I.B. Tauris & Co. Ltd
6 Salem Road
London W2 4BU

Distributed in North America by
Palgrave Macmillan, a division of
St Martin's Press
175 Fifth Avenue
New York NY 10010

© Rode Hall and Julie McKeown 2006

All rights reserved. No part of this publication may be reproduced, stored
in a retrieval system or transmitted in any form by any means mechanical,
electronic, photocopying or otherwise, without the prior written
permission of the publisher.

Designed by Norman Turpin
Printed and bound by Everbest, China

ISBN 0 85667 631 4 (hardback)

Contents

Foreword	6
Author's Preface	8
Pedigree of The Baker Wilbraham Family	9
1 The early life of Rode 1669–1770	10
2 The Bootles	28
3 Regency Rode	80
4 Victorian Arts and Crafts at Rode	98
5 The last century	114
Notes	136
Credits	142
Acknowledgements	139
Select Bibliography	141
Index	144

Foreword

THIS BOOK EXPLORES the unique development of the ceramic collection which still exists in Rode Hall, for which the successive generations have acquired, enhanced and maintained the range of ceramics for both decoration and use. Patronage of the ceramics industry, in its many forms, is not only clearly demonstrated in the surviving collections within the house but well delineated in this excellent descriptive study of these collections. This book places the ceramics in period context, with interesting snippets of family history, details of the building and enlargement of their houses, especially the property which eventually formed Rode Hall, the gardens and surrounding landscape, as well as contemporary details not only of life in Britain but the ceramic industry worldwide, bringing the collections alive to the reader.

The detailed explanation of the philosophy behind the purchases, by successive generations, makes a fascinating study. The explanation of the essential concept that wares in Rode Hall, now largely revered as museum pieces, were purchased primarily for domestic use adds a new dimension to the study of this subject. From seventeenth-century brown stoneware vessels, the tin-glazed posset pot, the highly decorative dessert wares symbolic of elegant dining in the eighteenth century, to the large range of wares purchased from the nineteenth-century ceramic industry, in the adjacent counties of Shropshire (Caughley and Coalport) and Staffordshire, from the most celebrated potters of their day providing a clear indication of the ceramic needs of such families.

This book splendidly links this extraordinary collection to the life and times of the inhabitants of Rode Hall and provides an excellent general introduction to ceramics from a different approach. Superbly researched, this is more than a ceramic history, it is a refreshingly honest social history of the Wilbraham family and their collecting habits through nearly three and a half centuries. This fascinating account of

one family's life within the elite of the eighteenth century in particular, provides a perfect background and explains admirably why certain ceramics were bought and how the social standing of a family could be so clearly reflected in their material possessions. The first-hand information on the tea trade and imported armorial oriental ceramics, through Captain Bootle and his voyages, gives a very different insight into this important aspect of eighteenth-century commerce and trade.

The important relationship between Walter Crane and the Wilbraham family at Rode adds much to our understanding of this particular aspect of the Arts and Crafts movement, an area which has been neglected in recent years. This unusual alliance provides an insight into another aspect of the interaction between artistic patrons and the craftsmen of the day.

It is appropriate that amongst all the detailed information the earliest documented order for Rode Hall was from Wedgwood's manufactory in 1769 – an association which was maintained through several generations through to the present day. It is therefore a great privilege to write the foreword to this fascinating account and delightful narrative of the lives, tastes and collecting habits of the owners and chatelaines of Rode Hall.

Gaye Blake Roberts
Director
THE WEDGWOOD MUSEUM TRUST

Author's Preface

The important collection of ceramics at Rode Hall has its foundations in the eighteenth century when Mary Bootle married into the Wilbraham family. An heiress to two fortunes, her love of fine china was a legacy which has been sustained over eight successive generations. Since 1980, the collection has been significantly enhanced by the current custodian of Rode, Sir Richard Baker Wilbraham, 8th Bart. His acquisitions especially reflect Mrs Bootle's early patronage of porcelain, both Chinese and English, and the family's subsequent interest in Victorian Arts and Crafts pottery, particularly the designs of Walter Crane who, as a young man, often visited Rode.

Much of Rode's collection has a horticultural focus which mirrors not only the ceramicist's continuing interest in the natural world but also the Wilbrahams' long-standing love of gardens. This is as evident in specially commissioned contemporary studio pottery as it is in exemplary pieces from the principal porcelain factories of the eighteenth century. The display of teapots from that period and the important Derby botanical dessert service commissioned by Mrs Bootle in 1787 are amongst highlights of a quintessentially English ceramics collection. It is fitting that its home is Rode Hall, a Georgian country house set in a Repton landscape. The Cheshire estate has been owned by the Wilbraham family since 1669 when the nation's pottery industry was in its infancy and the recipe for European porcelain had yet to be discovered.

The Baker Wilbraham Family

Roger Wilbraham (1623–1707) m. Alice Wilbraham

Randle Wilbraham I (1663–1732) m. Mary Brooke

Randle Wilbraham II (1694–1770) m. Dorothy Kenrick

Rev. George Baker of Modbury, Devon, Archdeacon of Totnes (b.1687) m. (1) Bridget Harris (2) Mary Weston

Richard Wilbraham (1725–96) m. Mary Bootle (1734–1813)

Sir George Baker, 1st Bt. (1723–1809) m. Jane Morris

Edward Bootle-Wilbraham Lord Skelmersdale (1771–1853)

Randle Wilbraham III (1773–1861) m. (1) Letitia Rudd (d.1805) (2) Sybilla Egerton (d.1868)

Sir Frederick Baker, 2nd Bt. (1772–1830) m. Harriet Simeon

Maria Charlotte Baker (d.1840) m. Sir John Hutton Cooper

Randle Wilbraham IV (1801–87) m. Sibella Egerton (d.1871)

Gen. Sir Richard Wilbraham (1811–1900) m. Elizabeth Frances Egerton (d.1849)

Sir George Baker, 3rd Bt. (1816–82) m. (1) Mary Sutton (2) Augusta Fitzwygram

Sir George Barrington Baker, 5th Bt. (1845–1912) m. Katharine Frances Wilbraham (1849–1945)

Sir Frederick Baker, 4th Bt. (1843–1911) (assumed surname of Rhodes)

Sir Philip Baker Wilbraham, 6th Bt. (1875–1956) m. 1901 Joyce Christobel Kennaway (1876–1958)

Sir Randle Baker Wilbraham, 7th Bt. (1906–80) m. Betty Ann Torrens (1906–75)

Sir Richard Baker Wilbraham, 8th Bt. (1934–) m. 1962 Anne Christine Peto Bennett (1936–)

CHAPTER ONE

The early life of Rode
1669–1770

Roger Wilbraham of Nantwich (1623–1707)

An° 1669 I purchased of Randle Rode, Esq. his moiety of the Manor of Rode, the Manor House and ye Domain Lands thereunto belonging… [1]

THESE WORDS, written in a family diary by Roger Wilbraham, record the year that Rode was first acquired by the Wilbrahams. The estate, near Congleton in south-east Cheshire, has been in the family's ownership ever since.

Descended from Sir Richard de Wilburgham, Sheriff of Cheshire in 1259, the Wilbrahams were by the mid-seventeenth century prosperous and influential landowners in Cheshire. Roger Wilbraham belonged to a younger branch of the family,[2] resident at Townsend House[3] in Nantwich, less than twenty miles from Rode. Educated at Repton and Cambridge, he joined Lincoln's Inn in 1642 and was called to the Bar in 1649. Like his forebear, Roger Wilbraham also held the office of Sheriff of Cheshire, being appointed in 1669, the year he agreed to purchase Rode.

Until that time the estate had been owned by Randle Rode whose early ancestors had taken their surname from land they acquired in the Saxon manor of Odrode (now the parish of Odd Rode). Records suggest some rivalry between the Rode family and their near neighbours, the Moretons, also Norman landowners. In 1514, this hostility had surfaced in a dispute over 'which of theym should sit highest in churche and foremost goe in procession'.[4] Over a century later the feud was forgotten, as the same parish church in Astbury witnessed the marriage of Randle Rode and Elizabeth Moreton. They were to settle at Rode, not far from

The earliest item of English porcelain at Rode (see page 134, fig. 128).

1. Randle Rode's receipt from Roger Wilbraham for the purchase of Rode, 1671.

Elizabeth's family home, the Tudor moated manor house, Little Moreton Hall.

Randle Rode's decision to sell Rode in the late 1660s was in effect forced upon him when, having spent all his funds supporting the King's cause during the English Civil War, he found himself unable to repay his loan on the estate. When his solicitor foreclosed, Randle appealed to Roger Wilbraham, thought to be his cousin, who agreed to purchase Rode. After protracted negotiations, 'Cos.' Randle Rode's receipt of '£2,400 of lawfull English money' was finally sealed on 4 May 1671. (Fig. 1) Not only was this sum twice that offered by the solicitor, but Roger Wilbraham also ensured that Randle was accommodated in a fine timbered house, which still bears his name, close to the market town of Sandbach in Cheshire.

As Roger Wilbraham continued to live at Townsend House, his reasons for purchasing Rode are not clear. Like many of the gentry, he might have been planning to move away from an increasingly busy urban environment to a nearby rural location where 'the place is helthy, and through the distance from the bodye of the Towne, the noyse not much.'[5] The early Restoration period (1660–85) was also a time of widespread architectural change in England as many previously exiled royalists returned from Europe to rebuild their properties in the latest French, Dutch and Italian styles. Inspired by these schemes, it is possible that Roger Wilbraham intended to renovate or rebuild the probably half-timbered manor house at Rode for his own use. Purchase of the estate's dairy house, water corn mill and 'divers pastures and parcells of land' also represented a sound investment in Cheshire's dairy-farming industry[6] and a guaranteed source of income for his children.[7]

Sadly, his two eldest sons died in 1676, the year after the death of his wife of twenty years, Alice (née Wilbraham of Dorfold), events which may have postponed any immediate plans for Rode. Remaining in Nantwich, Roger Wilbraham continued to play a beneficial role in the town, where he built Alms Houses in memory of his wife, whilst supporting his surviving family: his daughters, Alice and Grace, and his sons, Stephen and Randle.

Pottery and porcelain of the seventeenth century

The Restoration period also saw the English adopt from continental Europe a taste for more opulent decoration in interior art and design, with rich tapestries, wood panelling, lavish upholstery and carved furniture. Unfortunately, no descriptions of the interior of seventeenth-century Rode survive but it is known that the Wilbrahams had already furnished Townsend House, a fine brick-built mansion, with costly fittings, including stained glass supplied by Dutch craftsmen.[8]

At that time, the wealthiest households still preferred silver to

ceramics and it seems that Townsend was no exception. However, the theft of a quantity of plate caused Roger Wilbraham to reconsider his evident fondness for fine possessions. His diary entry for 1679 records:

> I made all ye Enquiry I could, sint ye marks of yr plate I lost to all ye Markt Towns within 20 miles round us, But could make no discovery. I looked upon this dark Providence to be to me to sett loose to those transient things which ye worth of men may take from us.

A will he made in 1687, twenty years before his death, suggests some difficulty in keeping this resolution. To his elder son and heir, Randle, who was to inherit Rode, he bequeathed several items of silver 'that these may goe for Heir-Looms to the Family' and also 'one legacy more (& hope it may not be the least in his esteem) that is, my papers & collections which he will find in my Cypress Cabinet to serve him both for a divertissment & an inducement to retire into himself.'

Whether Roger Wilbraham's cabinet of curiosities contained any specimens of porcelain and pottery is not known. The technological advances and varied designs of imported oriental and European ceramics had initiated the development of many more diverse and decorative types of earthenwares in England. A variety of local clays, coal fuel and good communications were already establishing north Staffordshire as an important centre for pottery manufacture. From his home in the neighbouring county, Roger Wilbraham would have noted the commercial success of its slipware, such as that made by the Toft family. This innovative style of decoration using 'slip' (liquid clay) was indicative of the skilled craftsmanship which was to further develop in north Staffordshire in the following century.

Whilst slipware and country pottery found a market with the less affluent rural population, a more refined type of earthenware was favoured by the wealthier urban classes. This was delftware, an attractively decorated tin-glazed earthenware made in imitation of Italian maiolica, French faience and Dutch Delft. By the mid-seventeenth century English delftware factories in Lambeth and Bristol were supplying the nobility and gentry with elaborately shaped posset pots and salvers, as well as large decorative dishes such as tulip chargers.

A posset pot is amongst a number of examples of English delftware at Rode, although it is not known if it belonged to Roger Wilbraham. The only ceramics specifically mentioned in his 1687 will were 'three stone potts bound with silver & gilt'. These vessels were probably made of salt-glazed stoneware, a material then precious enough to be mounted with silver-gilt. Described then as family heirlooms, the pots almost certainly originated from the Rhineland or the Low Countries as it was not until the 1670s and '80s that the ceramic chemist John Dwight mastered the production of salt-glazed and red stonewares in England. Like Roger Wilbraham, Dwight had a legal training and was

also resident in Cheshire during the 1660s when he was employed as Registrar for the diocese of Chester. It is an intriguing thought that church matters may have brought the two men into contact before Dwight embarked on his ceramics experiments in Wigan and London.

Dwight's innovations were to have a major impact on the development of the Staffordshire potteries in the early eighteenth century when successful production of white salt-glazed stoneware was achieved. A white-coloured ceramic had long been the goal of European potters and was much sought after by those who could afford to purchase it. An inventory dating back to 1612[9] shows that Roger Wilbraham's great grandfather, Richard Wilbraham, had owned 'one white Cupp for beere' and 'one nest of whyte bowles w(i)th a cov(er)'. The early date and description suggest the items might have been continental stoneware or perhaps tin-glazed earthenware. However, their exceptionally high values, 20 shillings and £6-0-0 respectively, imply rather the material that those earthenwares only aspired to imitate: Chinese porcelain.

Fine, pure white porcelain of the late Ming Dynasty (1368–1644) had first been imported into Europe by the Portuguese in the fifteenth century. By the early 1600s, the Dutch and English East India Companies, established to compete in the lucrative spice trade in Asia, were also beginning to include this commodity amongst other rare and luxurious imports: Chinese tea and silk, Japanese lacquer, Indian textiles and West Indian reserves, such as gold, tobacco and sugar.

It was not until the end of the seventeenth century that porcelain became especially desirable in England, its popularity given impetus by an event noted by Roger Wilbraham in the family diary: the arrival of William of Orange 'on board the Dutch Fleet … on our coast, 5 Nov 1688.' During their joint reign (1689–1702), King William and Queen Mary are credited with introducing a number of enduring passions to the English, all of which were to be embraced by the Wilbraham family over the centuries. These were gardening, paintings, silks and calicos, and, of course, porcelain. Queen Mary amassed vast collections of blue-and-white 'china' (the name then given by Westerners to imported Chinese porcelain) at the Water Gallery at Hampton Court and her palace in Kensington. Her lavish decorative displays, designed in the Baroque style by the French Huguenot Daniel Marot, were much imitated by the aristocracy and gentry. Daniel Defoe was to write:

> The queen brought in the custom or humour, as I may call it, of furnishing houses with china-ware, which increased to a strange degree afterwards, piling their china upon the tops of cabinets, scrutores, and every chymney-piece, to the tops of the ceilings, and even setting up shelves for their china-ware, where they wanted such places, till it became a grievance in the expence of it, and even injurious to their families and estates.[10]

The esteem of Chinese true or 'hard-paste' porcelain had inevitably led

to a quest to develop imitations in Europe. However, although there were some isolated trials, its manufacturing methods and materials – firing a raw mixture of white china clay (kaolin) and china stone (petuntse) – remained a mystery throughout the seventeenth century. Makers of salt-glazed stoneware and tin-glazed earthenware made attempts to reproduce the exquisite whiteness of porcelain, but the resultant dense and dull clay bodies could not replicate the elusive delicacy and beautiful translucency of porcelain. It was not until c.1707–10 that the alchemist Johann Frederich Böttger finally discovered the formula for true porcelain in Europe, at the Saxon factory of Meissen, near Dresden in Germany.

The first house

Roger Wilbraham did not live to see the production of European porcelain. He died on 5 March 1707 'at Rode', an event recorded in the family diary by his son and heir, Randle Wilbraham, the first of four Randle Wilbrahams of Rode.

Randle Wilbraham I (1663–1732) (Fig. 2) is distinguished by having replaced the old half-timbered hall at Rode with a new brick house. Built in c.1705, it now abuts the later second house but for nearly fifty years this smaller, west-facing building stood alone: a hip-roofed, two-storey construction with lead-paned cross windows in a slightly recessed five-bay centrepiece. In the mid-eighteenth-century Venetian and *oeil-de-boeuf* windows were erected inserted into the wings and a new semi-circular headed central doorway was installed. By the early 1800s, a distinctive cupola had also been built between its tall chimneys. Before these later additions, the house's long and low rectilinear form and simple, unpretentious façade typified the domestic architectural style of the reign of Queen Anne (1702–14).

Unfortunately, Randle Wilbraham's expenditure was not equally modest and costs incurred by building Rode's new house were evidently a drain on his resources. By 1708 his funds had seen some recovery; in a note penned on 25 March of that year, Randle I reflected that in spite of his 'Tenne Children borne (wch occasions are said to bee expensive)' he had saved enough of his income 'as hath defrayed the charge of my building and furniture att Rode and discharged some part of that Debt which my youth and folly had contracted which I must impute (next to the Blessing of Almighty God) to ye management of a prudent yoakfellow…'

This 'prudent yoakfellow' was Mary Brooke, daughter of Sir Richard Brooke, 2nd Bart, of Norton Priory in Cheshire, whom he had married in 1687. Like his father before him, Randle had been Cambridge educated and later appointed Sheriff of Cheshire. He also retained Townsend House but it is not known whether he took the

2. Randle Wilbraham I (1663–1732).

paternal advice suggested in Roger Wilbraham's will to immerse himself in his 'papers and collections', either there or at Rode. Randle's own will, made a year before his death in 1732, makes no mention of 'china' amongst 'Goods, Plate, Linen, and other Household Stuff' left to his wife. After Randle's death Townsend passed to Roger, his eldest son and heir, and thereafter to the Wilbrahams of Nantwich and Delamere, whilst Rode was inherited by his second son, also called Randle.

The second house and gardens

Under the tenure of Randle Wilbraham II, LL.D (1694–1770), (Fig. 3) Rode was to be developed into an important Cheshire seat. However, its transformation was delayed for some thirty years after Roger Wilbraham's death whilst Randle II, supported by his wife Dorothy (née Kenrick of Woore), continued to advance what was to be a distinguished legal and political career.

Educated at Brasenose College, Oxford, Randle II had been called to the Bar in 1718 at Lincoln's Inn where he was subsequently elected treasurer. Horace Walpole, in a letter of 1746, described him as 'a very able lawyer' whilst Chief Justice Wilmot was to write on his death in 1770 that Randle II 'has not left a better lawyer, or an honester man, behind him.'[11] He was equally respected as a politician, sitting as a Tory member for Newcastle-under-Lyme in Staffordshire, a short distance from Rode (1744–47), and afterwards for Appleby in Westmorland (1747–54) and the Lancashire town of Newgate (1754–68). In addition he was also elected Vice-Chamberlain of Chester and Deputy Steward of the University of Oxford.

For several months of each year, professional preoccupations inevitably kept Randle II at his London home in Bedford Row rather than in Cheshire. However, a country house said much of a gentleman's status in Georgian England and this consideration might have prompted Randle to build a new house at Rode in 1752.[12] An added impetus at that time may well have been the desired marriage of his twenty-seven-year-old son and heir, Richard, whose eligibility would be further enhanced by improvements made to the family estate.

The new house at Rode did not replace the old one but was built to the north west of it. (Fig. 4) At two-and-a-half storeys high and five bays by four, it was considerably larger than the earlier house which was then turned into a service wing accessed through an arcaded courtyard. Before the substantial alterations of the early 1800s, the second house presented a very plain façade of red brick with white stone architraves. Influenced by the Palladian style of architecture still fashionable in England, it retained the simplicity of the earlier building but, unlike that, its entrance, a classical Doric portico with inner and outer carved entablature, faced northwards towards what is now the garden.

3. Randle Wilbraham II (1694–1770), a portrait painted by Thomas Hudson.

4. Rode Hall, with the first house of c.1705 to the right and the second house of c.1752 to the left.

The architect of the house is not known but it is believed that he was based outside London. The two-storey three-side bays at the east and west elevations recall the work of Sir Robert Taylor who built nearby Barlaston Hall, close to Trentham, in 1756. However, a first-floor Venetian window lighting the staircase at the back of the house suggests the work of one of the Hiorne brothers, David or William, of Warwickshire. Other stylistic evidence presented by a surviving ground floor plan of 1752 would seem to support this. The same plan is shown on a portrait of Randle II painted by the eminent society portraitist Thomas Hudson (1701–79); it is depicted, significantly, beneath works by two notable English jurists: Commentaries by Edmund Plowden and a reprint of Littleton's treatise on tenure included in the first of Sir Edward Coke's four Institutes.

Coke, the champion of common law, had famously written 'A man's house is his castle,' an extract perhaps known to Randle II when in 1754, the year his wife died, he commissioned the building of a picturesque 'castle'. Designed as a two-storey circular castellated ruin, 'Wilbraham's folly' was constructed by local stonemasons Ralph and

5. (opposite). A pair of silver-shaped Chelsea plates with O'Neale Fable decoration, 'The Leopard and the Fox', left, and 'The Lion and the Frog', right, c.1752 (diameter 8 ½ in, 21.5 cm).

John Harding at Mow Cop, just a few miles from Rode. It was used as a summerhouse by the family for generations and still remains today, a distinctive eye-catcher high up on the craggy horizon of the Cheshire-Staffordshire border.[13] Mow Cop castle, now a National Trust property, is one of the country's earliest follies, built only a few years after the opening of a sham castellated tower at Edgehill in Warwickshire. This had been designed by the architect Sanderson Miller (1717–80), a Gothic revivalist known to have collaborated with the Hiorne brothers.

Miller and the Hiornes were amongst a growing number of architects also involved in landscape design, the gardening movement which had developed in eighteenth-century Britain. Humphry Repton, who coined the phrase 'landscape gardening', was to supply a Red Book for Rode in 1790 but it is not known who planned the garden before then. The Wilbrahams had been enthusiastic gardeners since at least Elizabethan times. Then, Richard Wilbraham had created for Townsend House an impressive walled garden, elaborately laid out with an arbour and banqueting house, columns and canals, and other fashionable conceits.[14] For advice on its herbs and plants, he may well have consulted the celebrated 'Herball', written by the surgeon and botanist John Gerard who was born and grew up in Nantwich. King James I almost certainly visited the garden whilst a guest at Townsend House in 1617.

The family's interest in gardening continued at Rode. A reference to Roger Wilbraham's 'orchards, gardens and courts within the Greene before ye hall' in a 1624 survey of Rode suggests a symmetrical Tudor garden (much like that at Little Moreton Hall) though this was probably significantly changed or destroyed when Randle Wilbraham I built the first house in c.1705. Then, economic constraints on the landlord class as much as changes in fashion were leading to a rejection of Renaissance and Baroque formality in gardens, whether Italian, French or Dutch in manner. Instead, a new British style of gardening was emerging in which gardens were opened up to the immediate countryside. Leading this fashion was Charles Bridgeman, royal gardener to King George II, who pioneered the use of the sunken ditch or ha-ha, like that at Rode, which marked an invisible boundary between garden and estate.

Ostensibly more naturalistic, and hence less expensive, in reality these new schemes were to become as artificial and as costly as earlier formal designs. By c.1730, the wealthiest landowners were following the trends set by the landscape gardener William Kent by surrounding their neo-Palladian country houses with hugely expensive gardens reshaped to represent a classical arcadia. Reflecting the poet Alexander Pope's words, 'all gardening is landscape painting', their parklands became vast canvases for scenic lakes and picturesque pathways leading to romantic grottos and garden temples evoking Grand Tours to Italy.

Since Rode had to wait until the early 1800s for a rustic fossil-lined

grotto, Randle Wilbraham's Gothic folly at Mow Cop remained the most striking addition to the landscape surrounding its more modest gardens. For most of the intervening fifty years, garden design was dictated by the radical landscape gardener Lancelot 'Capability' Brown, whose ambitious improvements on nature presented broad, open vistas sweeping up close to his clients' country houses. With curvilinear lakes and shady clumps of trees, such designs appealed to landowners whose parkland had to function as both a private pleasure garden and a source of agricultural revenue.

The estate at Rode provided enough produce for the Wilbraham family's own table: from its arable pastures; its fish pools and stew ponds, and its kitchen garden (originally in the area now known as the Meadow Planting). Food stuffs were then usually kept cool in the kitchens by using ice. Rode, in common with many of the wealthier estates, was fortunate enough to have its own ice house: an underground brick-lined, ovoid-shaped pit, some thirty feet deep, with a drain at its base. Restored in the 1980s, the ice house lies to the south of the house, its original 'L'-shaped, north-facing entrance shaded by trees. Although not far from the service wing, the garden staff had some distance to go to collect the ice from the estate's pools. This they delivered to the ice house through a hole in its grassed-over roof before packing it down with salt, straw and water. Kept in this manner, ice could be preserved

for up to two years. As well as acting as a cooling agent, it was also used in the preparation of ice cream, a confection which became popular in the second half of the eighteenth century.

Dinner guests would have found the interior of the house quite different from its current layout. Until the early 1800s they were received in the original north-facing square entrance hall, today's octagonal ante-room. A right turn would take them to the dining room, now the library. Typically this was the best room in the house where dinner was served, on special occasions, by liveried footmen. Following dessert, ladies would retreat to the drawing room, which at Rode has retained its original use and location to the left of the ante-room. The sexes so divided, the women could pursue their more polite pastimes away from 'the noise and talk of the men when left to the bottle.'[15] Corresponding rooms at the back of the house were for the Wilbraham family's more informal or private use: the old library, subsequently extended to create the present dining room, and the breakfast parlour, which together with the old back stairs form today's entrance hall.

In the very centre of the house was the stair hall, the only room whose original interior remains unchanged. Still dominating the hall is the staircase leading up to the owners' and guests' apartments; this impressive wooden structure boasts two fluted and scrolled balusters to each tread and a handrail made of mahogany set into oak. The plasterwork to the ceiling beneath the landing is perhaps that of the Shrewsbury architect Thomas Pritchard (1723–77), who also worked at Tatton Hall. Its ornate decoration, which includes a fine eagle, suggests that, in common with many buildings of the mid-eighteenth century, Rode's rather austere classical exterior belied a more flamboyant rococo interior.

Advances in porcelain and pottery manufacture

The picturesque, serpentine 'line of beauty' which characterised the French Rococo style was enthusiastically adopted by many British craftsmen, including those working in the pottery industry. Largely without royal or aristocratic patronage, the nation's potters still lagged behind their continental counterparts in the production of true hard-paste porcelain. It was not until 1768, following his earlier identification of deposits of china clay and china stone in Cornwall, that William Cookworthy (1705–80) patented its manufacture at Plymouth and subsequently at Bristol. However, the preceding years saw many other exciting innovations in English ceramic manufacture.

Notable amongst these advances was the development, from French forerunners, of various types of artificial or 'soft-paste' porcelain. The semi-translucency of this low-fired ceramic body was achieved by 'fritting' (heating and mixing into a paste) a white-firing ball clay with glass

6. An étui in the form of an asparagus spear, produced by Charles Gouyn's 'Girl-in-a-Swing' factory in St James's, c.1749–59 (length 5 in, 12.5 cm).

and its constituent parts. By the time the Wilbrahams took residence in Rode's second house in 1752, soft-paste porcelain had been manufactured commercially in England for several years. The earliest established works was at Chelsea in 1744–45, with other London factories following soon after, at Limehouse, Bow, St James's and Vauxhall. Principal producers elsewhere in the country included Longton Hall in north Staffordshire, and the Derby, Worcester, Lowestoft and Liverpool factories. Each factory developed its own recipe by adding a variety of strengthening materials, primarily bone ash or Cornish soapstone, to the glassy soft-paste body.

A wave of immigrants (many of Huguenot origin) brought to the ceramics industry new inventive skills, some adapted from other crafts. The silversmith Nicholas Sprimont (c.1716–71), for example, transferred a number of his silver shapes onto porcelain during the early years of his ownership of the Chelsea factory (Fig. 5), whilst his one-time partner and manager, Charles Gouyn (d.1785), integrated the metal-mounting techniques he had previously used as a jeweller into the small, decorative 'toys' he produced from 1749 at his 'Girl-in-a-Swing' porcelain factory in St James's (Fig. 6).

New methods of manufacture were absorbed and developed both within individual factories and also at the independent workshops they generated. By the end of the 1750s an increasingly mobile workforce could find a variety of employment in the ceramics industry. Occupations included the shaping of porcelain and pottery, such as modelling, mould-making and slip-casting, as well as the process of decoration, chiefly painting, in either underglaze cobalt blue or on-glaze enamel, and gilding. An alternative or additional decorative method was that of transferring onto ceramics, by means of either a sheet of paper or a 'bat' of pliable glue, a design printed from an engraved copperplate. Most probably invented by John Brooks of Birmingham in c.1750, the system of on-glaze transfer-printing using the glue-bat method was also

7. A Worcester porcelain teapot and cover, with ribbed loop handle and facetted spout. Painted in colours over an unusual purple print of 'Sutton Hall' and, on the obverse, 'The Two Bridges', engraved by Robert Hancock, c.1760–65 (height 5 ½ in, 14 cm).

8. A London-decorated Chinese porcelain teapot and cover, with a watery landscape scene with European figures finely painted in black by J H O'Neale and washed over in green monochrome, c.1765 (height 5 ½ in, 14 cm).

9. Lid-less sugar bowl from a rare single tea service. Giles-decorated in imitation of Meissen, with three quatrefoil panels with purple monochrome painted flowers and a jade-green ground with a gilded diapered 'mosaic' pattern, Worcester, c.1763–68 (height 3 in, 7.6 cm).

10. A slop bowl of fluted form, with Chinoiserie-style decoration from the Giles atelier of a cormorant on a turquoise rock with a golden fish in its beak, Worcester, c.1765 (height 3 in, 7.6 cm).

adopted from around the same time by the independent Liverpool-based firm of John Sadler (1720–89) and Guy Green (d.1799). It was not until nearly ten years later that under-glaze transfer-printing in cobalt blue was developed, initially on soft-paste porcelain made at Worcester, the factory founded in 1751 by Dr Wall and his partners.

Designs were commissioned from numerous artist/engravers, many of whom worked freelance. One of the foremost engravers then was Robert Hancock (c.1731–1817) whose derivative figurative and landscape designs were amongst the earliest used at Bow and Worcester. (Fig. 7). Together with the Irish miniaturist painter Jefferyes Hamett O'Neale (1734–1801), who is probably best known for his Aesop's Fable painting at Chelsea and Worcester, Robert Hancock also contributed engravings to 'The Ladies Amusement'. This publication of 1759–60 became a valuable design source for freelance and factory-employed modellers, artists and decorators.

Of the independent decorating studios then in operation, that of the enameller and gilder James Giles (1718–80) was probably the most successful (Figs. 8–16). Today his London atelier is acknowledged as having produced some of the finest ceramic decoration of the eighteenth century. Giles worked on Chinese, Chelsea, Vauxhall, Liverpool and Derby porcelain but more usually on Worcester blanks and part-decorated wares which he purchased from the factory between c.1765 and c.1775. His various subjects included watery landscapes in green or carmine; freely painted fruit and flowers; figures in a rustic Teniers- or romantic Watteauesque-style; and birds, painted either naturalistically or as exotic fiery creatures. Additional decoration favoured by Giles on Worcester wares included cornucopia-shaped borders, often painted in variously coloured scale grounds, and a distinctive ciselé gilding, used especially on underglaze blue and blue scale grounds. (Giles also decorated glass and examples from the 1760s–70s may be seen amongst the collection of glassware at Rode.)

The style of English ceramic design initially imitated that of imported porcelain: either oriental – from China and Japan, or continental – chiefly Meissen from Dresden in Germany and Vincennes and Sèvres from France (Figs. 17–18). Inevitably, entrepreneurial manufacturers began to adapt designs or originate fresh ones which specifically catered to English taste, simultaneously developing new skills in sales distribution and marketing. The hub of the ceramics industry's commercial activity was London, long established as a centre for the East India china trade. From the mid-eighteenth century new wholesale warehouses were opened, selling English porcelain and pottery both direct to the general public and also to specialist ceramics dealers. Such 'chinamen' were either already employed as traders in imported Chinese porcelain (and tea) or were independent retailers, some of whom were also skilled craftsmen, such as jewellers, goldsmiths, toymen and

confectioners. Advertisements, trading cards and newspaper 'puffs' trumpeting the latest luxury lines were all means of luring a new leisured class for whom shopping had become a pleasurable pastime. Special ceramics exhibitions and auction sales also became de rigueur events attended by the nobility and gentry, whilst elegantly decorated showrooms promoting new artistic wares provided a rendez-vous for the fashionable wives of the wealthy.

Josiah Wedgwood and Randle Wilbraham II

'Shoals of ladies' were to visit the London showrooms of Josiah Wedgwood (1730–95), though it is not known if any Wilbraham wives were amongst them. One of the country's leading entrepreneurs, Wedgwood's knowledge of cost-effective pottery production and his enthusiasm for scientific ceramic experimentation owed much to his partnership between 1754 and 1759 with the master potter Thomas Whieldon (1719–95). Whieldon had improved on most of the wares then made in north Staffordshire's 130 plus working potteries. These included salt-glazed stonewares, red or black lead-glazed earthenwares, the pseudo-Chinese red stoneware previously produced by the Elers brothers, and the lead-glazed cream-coloured earthenware known as creamware. In partnership with Wedgwood, he further developed his agate ware, produced by wedging different coloured clays together; tortoiseshell ware, made by sponging metallic oxides on a creamware body; and green glazed ware, a range of earthenware shapes, especially

11. Giles-decorated teawares with Meissen- and Sèvres-style patterns, all with Worcester's 'crossed swords and 9' mark in underglaze blue (diameter of saucers 5 in, 12.5 cm). Left to right: Tea cup and saucer with irregular-shaped purple scale border and painted with cut fruit, flowers and fungi, c.1769; coffee cup and saucer with an unusual claret ground and gilded reserves painted with European flowers, c.1770–72, and teacup and saucer with *bleu-celeste* ground and gilt-bordered cloud-shaped reserves painted with fruit and flowers, c.1765–68.

12. A fine Worcester Dr Wall period barrel-shaped teapot and cover, decorated in the London atelier of James Giles with an irregular apple-green border outlined with gilt and painted European flowers, c.1772 (height 5 ½ in, 14 cm).

teapots, naturalistically moulded as either common vegetables, such as cabbages and cauliflowers, or exotic fruits, like pineapples and melons.

As an independent producer from 1759, Josiah Wedgwood continued to manufacture a green glaze for several years before its revival in the nineteenth century for leaf-moulded dessert wares. However, his major interest was in developing the functional heat-resistant cream ware into a more refined and sophisticated product. Whilst hand-painting with on-glaze enamels was a popular method for its decoration, from 1761 Wedgwood entered into an agreement with Sadler & Green for their on-glaze transfer-printing. This had previously been used on enamels, delftware and Liverpool, Longton Hall and Worcester porcelain but proved especially successful on creamware. Elegant yet inexpensive, the product soon found favour with the wealthier classes of

13. Two Giles-decorated Worcester shell-moulded sweetmeat dishes, with deep-pink borders and wild strawberries (left) and iron red cherries (right) painted in the centres, c.1768 (width 5 in, 12.5 cm).

society for whom pewter was outmoded, delftware impractical and soft-paste porcelain still too expensive for everyday use. Wedgwood's manufacturing skills were matched by a supreme talent for marketing and when in 1765 the wife of King George III, Queen Charlotte, ordered cream ware tableware, the potter promptly publicised his product as 'Queen's Ware'.

Capitalising on his royal patronage brought commercial success and funds for further experimentation. The designers of Wedgwood's ornamental tinted dry-bodied stonewares, Black Basalt and Jasper, took advantage of the increasing interest in antiquarianism and Neo-classical decoration then prevalent amongst the prosperous cognoscenti, many of whom were introduced to the potter by his loyal friend and partner, the Liverpool merchant Thomas Bentley.

Bentley did not instigate Wedgwood's acquaintance with Randle Wilbraham II during the 1760s, though doubtless he encouraged such a valuable professional and social contact. North Staffordshire's burgeoning ceramics industry was familiar to Randle II through both his parliamentary and legal offices. As MP for Newcastle-under-Lyme during the 1740s he would have known of Samuel Bell's production of red earthenware and the Pomona Works' soft-paste porcelain, whilst there is evidence that in 1760 he ruled on a legal case, allegedly eleven years in chancery, between 'two eminent potters of Handley Green, Staffordshire'.[16] By then, Randle II was sixty-six years old and Josiah Wedgwood a young man of thirty, making regular journeys to visit his distant cousin and future wife, Sarah. It was perhaps during one such visit that the two men first met, since Sarah's father, Richard Wedgwood, a wealthy cheese producer and independent banker, was one of the Wilbraham family's closest neighbours, his property in Spen Green lying immediately adjacent to the Rode estate. Across the fields was the parish church at Astbury which both families attended and where Josiah and Sarah Wedgwood married in 1764.

14. Two Giles-decorated Worcester porcelain sugar bowls and covers of identical form. That on the left is painted in colours with a bouquet of European flowers and that on the right features, more rarely, a naturalistic bird – a bullfinch – perched on a stringy, leafy branch, with carmine sprigs to the obverse and interior, c.1768 (height 4 ¾ in, 12.5 cm).

15. Junket dish of fluted form, with an irregular pink scale border and painted fruit and flowers typical of the Giles atelier, including rosehips, white currants, convolvulus, scarlet pimpernel, auricula and tulip with divergent petals, Worcester, c.1765–68 (diameter 9 ½ in, 25 cm).

The following year saw Wedgwood launch his campaign to construct the Grand Trunk or Trent and Mersey Canal, by which it was planned to transport raw materials in and pottery out of north Staffordshire to the port of Liverpool. Wedgwood had a special interest in this improved method of transportation as he was by then sending large quantities of his creamware to Liverpool for printing. To guarantee the success of his campaign, Wedgwood lost no time in rallying support from men such as Randle Wilbraham II, whose backing, as a wealthy landowner and influential member of parliament, was vital. From his Burslem pottery, he wrote to his friend, the physician, scientist and botanist, Dr Erasmus Darwin: 'And I am going to wait upon Mr Willbraham of Rhode [sic] with a plan &c to day, as he sets out for

16. Pair of rare Dr Wall Worcester scalloped-edged plates, each Giles-decorated with a large spray of flowers and scattered single flowers within a broad mazarine blue border and distinctive *ciselé* gilding, c.1770. Crescent and fretted square marks in underglaze blue (diameter 7 ½ in, 19.1 cm).

17. Worcester square-shaped dessert dish decorated with a dry blue bouquet of flowers to the centre and a Sèvres-style scrolling border of purple, *bleu celeste* and gold, c.1770. Items in this extremely rare pattern were presented by Queen Elizabeth II to US President Reagan during his visit to Britain in 1982 (diameter 7 ½ in, 19 cm).

London early in the Morning.'[17] Randle seemingly raised no objections and, following the plan's authorisation by Act of Parliament in 1766, allowed the canal to pass through '13 chains 84 links' of his land 'at the rate of £30 a statute acre'.[18]

It is not known whether the widowed Randle Wilbraham II purchased pottery from Wedgwood although there was an order made from Rode Hall during his occupancy. Dated 30 October 1769, it was written in the form of a letter addressed to Josiah Wedgwood but, interestingly, the writer signed himself 'John Antrobus'. He was most probably a member of the Cheshire family of Eaton Hall near Congleton, friends of the Wilbrahams, and might have been acting as a steward at Rode in Randle's absence. His letter of 1769, requesting unspecified goods 'with an addition of two more Quart Jugs', would appear to be the earliest documented order of ceramics from the house.[19] In the winter of the following year, 1770, Randle Wilbraham II died, leaving Rode to his son and heir, Richard. By then, Mary Bootle, Richard's wife, had already developed her fascination for fine ceramics which was to lay the foundation of the collection at Rode.

18. Chelsea-Derby teapot decorated with the Sèvres-style 'Hop-Trellis' pattern, c.1775. Gold-painted 'D' and anchor mark (height 6 ½ in, 16.5 cm).

CHAPTER TWO

The Bootles
Lathom, London and Rode

May 30th, Rch. Wilbraham Esq.; Son of Counsellor Wilbraham, to Miss Bootle.

THE SIMPLE ANNOUNCEMENT in *The Gentleman's Magazine* gives no indication of how good a marriage Richard Wilbraham (1725–96) was making when he took Mary Bootle (1734–1813) as his wife in 1755 (Fig. 19). For three years later, she was to inherit not only the fortune of her father, Captain Robert Bootle (c.1708–58), a Director of the East India Company, but also that left to him by her uncle, Sir Thomas Bootle (1685–1753), Chancellor to the Prince of Wales.

Although the Bootles could trace their ancestry as landed proprietors in Maghull, Lancashire, back to 1317, they did not come to prominence until the seventeenth century. Thereafter, Sir Thomas Bootle's manorial acquisitions included Skelmersdale in 1751 and his impressive country seat, Lathom, in 1724 (Fig. 20). Once the home of the Stanley family, ancestors of the Earls of Derby, Sir Thomas completed the rebuilding of Lathom Hall in 1734 to designs by the Palladian architect Giacomo Leoni (1686–1746), whilst his redevelopment of the surrounding deer park included the creation of a ha-ha and screening woods, ice houses and pleasure gardens with several water features. As a wealthy heiress-in-waiting to such a grand estate, Mary would have attracted many suitors but it was Richard Wilbraham, then a promising young Lincoln's Inn barrister,[20] whose proposal – and pedigree – proved most acceptable. Following his marriage to Mary, Richard complied with the conditions of Sir Thomas's will by assuming the additional name Bootle, thus ensuring its continuation for future generations.

In addition to family and fortune, Mary Bootle also possessed personality. Whilst the two paintings of her at Rode[21] portray the gentle expression of her youth and old age, George Romney's 'Portrait of Mrs

19. Portrait of Mrs Wilbraham Bootle, painted by George Romney in 1871 (The National Gallery of Scotland).

20. Lathom Hall, a watercolour sketch painted by a member of the Bootle-Wilbraham family in the nineteenth century (length approx. 3 in, 7.6 cm).

Wilbraham Bootle', now in the National Gallery of Scotland at Edinburgh,[22] captures the considerable strength of character she had developed by the time she reached middle age. This was especially manifested in the management of her domestic empires, a talent doubtless appreciated by her husband, especially when he assumed a second career in politics. The reciprocal prestige and pleasure offered by their complementary roles, matched by an affection and loyalty, were factors in their long and harmonious marriage.

The Loveday Letters: the correspondence of Mrs Bootle to Dr John Loveday

The prolixity of a female pen you will observe probably is equal to her tongue, difficult to be stop'd!
Mary Bootle to Dr John Loveday, 1789[23]

Much of what we know about Mary Bootle is gleaned from her lengthy correspondence with Dr John Loveday (1742–1809), a lawyer and antiquary of Banbury in Oxfordshire.[24] The two were cousins and shared common ancestry through Mrs Bootle's maternal great grandfather, William Lethieullier of Clapham in London, a Huguenot merchant trading in goods from Turkey.

Unlike the letters of well-known eighteenth century female writers such as Lady Mary Wortley Montagu, which were composed with a view to publication, those of Mrs Bootle constituted private and familiar exchanges of news and views. Covering a period of thirty-five years, from 1768 until 1803, the letters mostly chronicled the welfare and whereabouts of her extended family. However, aware that their recipient was a man of learning, hers was not 'a downright Chit Chat Female Epistle' but included opinions on broader cultural and state affairs,

national events and public figures. Her views were given special insight by the privileged access to London's social and political circles which she enjoyed as the wife of an MP.

Richard Wilbraham Bootle had joined his father in the House of Commons as the newly elected Member of Parliament for Chester in 1761 (Fig. 21). Representing the interests of the Earls of Grosvenor of Eaton Hall, he held the seat 'very respectably' until 1790 when, as Mrs Bootle commented further to Loveday, 'increasing infirmitys and natural indolence of temper will induce him not to seek another.' Newspaper reports indicate that he had not been a party man, the *English Chronicle* describing him as 'one of the most independent Members in the House' and the 'Public Ledger' reporting that the 'very honest man' chose to vote 'on both sides, according to his opinion.'[25] Politics remained an enduring passion of Mrs Bootle who was not afraid of expressing her viewss on those appointed to England's numerous ministries and administrations. At the time of her husband's resignation, she shared the country gentry's enthusiasm for William Pitt, but at the end of the Prime Minister's first ministry ten years later, she had cause to reconsider, writing: 'Mr Pitt and the King together have terribly undermined the constitution of this Country; and the respectable Country Gentleman is a character wearing out very fast…'

Richard Wilbraham Bootle's parliamentary career required the family to be in London from mid-November until June of each year, 'Northern Summers' being spent either at the main family seat of Lathom Hall or at Rode. Town life was certainly no hardship for Mrs Bootle who enjoyed keeping her country cousin up to date with the latest news from the 'smoky metropolis'. For the duration of the Wilbraham Bootles' married life, they maintained two homes in the capital: a suburban family villa in Southwood, near Highgate, which Mary had inherited from her father, and a central town house, originally in Ormond Street but subsequently in the smarter location of Bloomsbury Square where a 'spacious mansion' was maintained until 1799.

A grand Bloomsbury Square address was to prove no insurance against incident, as it was from there that the family was forced to flee in June 1780 as anti-Catholic Gordon rioters burned down the home of their neighbour, the Lord Chief Justice, Lord Mansfield. Giving 'directions to the few Servts that were in the house to make no Opposition if they came', the Wilbraham Bootles took temporary refuge with friends where they 'continued watching the Flames of 8 different fires'. Returning the following day, they found their house safe, although 'the Annals of England don't furnish such another Scene since the Rebellion in Richd ye 2nd time 401 years ago.' Two weeks later, the indomitable Mrs Bootle wrote from Rode's 'Peaceable fires' where 'Change of air, good hours and the perfect calm we live in has thank God made me more myself again.'

21. A copy of George Romney's 1781 portrait of Richard Wilbraham Bootle, painted by the Liverpool artist Thomas Allen in c.1804. His great girth made the sitter an ideal subject for eighteenth-century satirists. 'Last week', he recounted to the landscape gardener Repton in c.1790, 'they announced that I had been to see the great Lincolnshire Ox in hopes of seeing a greater beast than myself and today you see they have sent me and the fat Mrs Hobart up together in a balloon!'

22. Photograph of George Romney's 1781 portrait of 'Masters Edward Wilbraham Bootle and His Brother, Randle, When Boys.'

Georgian England still determined that genteel wives should provide their husbands with children 'of the best sort', namely sons to further the family line.[26] When Richard Wilbraham Bootle declined the offer of a peerage because he had no son, Mary Bootle must have felt especially burdened.[27] She was to give birth some twelve times before she presented Richard with his requisite heir and spare: Edward, known as 'Bootle', born in 1771, and Randle, called simply 'Wilbraham', born two years later. (Fig. 22) Inevitably, the boys' schooling, at Eton and Westminster respectively, and their early occupations absorbed much of their mother's writing but not at the expense of her six surviving daughters. Indeed, Mary's early feminist inclinations are revealed in her comments to Loveday on a poem written by the Poet Laureate, William Whitehead: 'I think the Fable is a Lesson of Humility to us Females to keep ourselves in proper Defference to the Superior Abilitys of the men, in which I am not intirely of his Opinion, as I think the Difference in the Sexes arises more from the Difference in the Mode of Education than from Natural Defficiency.' Nonetheless, she happily accepted the conventions of the time and makes no mention of her daughters' schooling, enthusiastically chronicling their marriages instead.[28]

Most auspicious of these was Anne Dorothea's to Richard Pepper Arden (1745–1804), later 1st Baron Alvaney.[29] Pepper Arden was a close friend of Pitt and Mrs Bootle was undoubtedly delighted when the Prime Minister agreed to act as godfather to her grandson, William. (As the 2nd Baron Alvanley, William Arden (1788–1849) grew up to be a great wit and dandy though is mostly remembered today as the recipient of Beau Brummel's famous jibe to the Prince Regent, 'Alvanley, who's your fat friend?'.) Declaring that 'we have never shewn ourselves mercenary in our alliances for our daughters', Mrs Bootle was nonetheless unable to suppress her pride when Pitt also appointed Richard Pepper Arden Master of the Rolls. Overlooking the 'Shabby Knighthood that attend the Office', she was forced to admit that 'A place for Life of 3500 a year revenue; Independent; a Seat in Parliament and much leisure time to the possessor; is certainly most desirable, and att the early period of 44 may be considered as most fortunate.'

The more sensitive and stoical side of Mary Bootle's personality was of necessity often expressed during an era when infant mortality was high and many young wives died in childbirth. A 'wound that however time may mitigate its poignancy, will never heal' described the death of her twenty-four-year-old daughter, Mary, after only four years' marriage to William Egerton (1749–1806) of Tatton Park in Cheshire. In that short time, Mary Bootle and her family had grown very fond of her son-in-law and he of them: 'indeed Mr Egertons extreme attachment to us is more like Kindred by Blood than by connection.' Thereafter, Mary Bootle continued to visit him and her grandchildren, the eldest of whom, Wilbraham Egerton (1781–1856), was to inherit Tatton in 1806.

A number of Mrs Bootle's letters were addressed from Tatton, conveniently equidistant between Rode and Lathom. Indeed, the family was frequently travelling between homes, as the season dictated, occasionally making diversions to places of interest, such as Audley End, 'a magnificent house and place belonging to Lord Howard of Walden.' Whilst other female letter writers, such as Mrs Delaney and the famous bluestocking, Mrs Montagu, relished describing grand houses, either their own or others', Mrs Bootle's correspondence is devoid of such accounts. The subject evidently interested her, however, as she wrote: 'I have a great turn for building, altering and improving, and have had great experience in these employments', but she perhaps considered it not of interest to the learned doctor. Disappointingly, her letters reveal very few details of the architectural and decorative schemes she employed in the Wilbraham Bootle homes and gardens.

Mrs Bootle did not avoid the domestic sphere entirely and she had much to write about such subjects as maladies and remedies, prices and recipes, and spas and the seaside. Whilst she favoured Bath for its waters, the fashionable resort of Brighthelmstone (now Brighton) was considered ideal for sea bathing; in the spring of 1777 Mrs Bootle spent '5 weeks in the most agreeable manner; was particularly fortunate in Meeting with a Set of Polite Sensible People that were well inclined to Promote Society, & to recommend themselves to each other; as much as possible; by whose means; the Sea Bathing, Sea Air & Relaxation from the Cares & Fatigues of a Burthensome Family I find myself restored to that Valuable Blessing Health…'

Although a quiet family with interests in literature and music, the Wilbraham Bootles also enjoyed the lively social life of London, Mrs Bootle commenting in 1789: 'We are head and ears in Balls and fetes, Whites, Brookes, Boodles, the French and Spanish Ambassadors all give Galas, the Queen and Princesses honour the two latter.' A devoted royalist, Mary faithfully followed the illnesses of King George III and reported on the ceremony she attended at St Paul's Cathedral to celebrate his recovery. The proclivities of his son, the Prince of Wales, 'a sad, debauched unprincipled young man', initially drew less sympathy but by the early 1800s she had mellowed, commenting that the Prince 'is growing very good, civil to the Kings friends, and respectful to his parents; his appearance is much alterd from the Stout Athletic figure, fat and high Spirited full of Laugh & talk; he appeard at the Ancient Music last Wedy (which he hates and used to call dull) but so thin, so puckerd his face and so quiet, that I really did not know him.'

Mrs Bootle was not above entertaining her cousin to a little scandal, recounting that 'the Extraordinary Elopement of Lord Coventrys son Lord Derehurst with a sister of Lord Northingtons causes such speculation, he is a Dissipated Reprobate Drunken Boy not 18, she a Thoughtless Wanton Girl of 19, their Acquaintance was of

3 days standing when the frolic was executed...' Occurring during the American War of Independence, Mrs Bootle was able to offer some crumbs of comfort: 'Lord Derehurst goes tomorrow for America, so she has some chance of getting rid of him.'

Such gossip was, however, infrequent and for the most part Mrs Bootle's letters maintained a high-minded tone. Although deferring to Loveday's antiquarian scholarship, she was widely read with a preference for history, religion and philosophy. Citing the works of such writers as Edmund Burke, David Hume, as well as 'your friend, Dr Johnson', she reserved rare praise for Hannah More's religious tracts whilst reviling Paine's 'Diabolical book', 'Rights of Man', by 'whose insidious circulation... the minds of the common people are workd up to rebellion'. Poetry must have provided a more calming pursuit for Mrs Bootle whose name appeared on the list of distinguished subscribers to the published volumes of the poet, novelist and letter writer Helen Maria Williams.[30]

Richard Wilbraham Bootle was also a patron of the arts and sciences. Elected a Fellow of the Royal Society in 1761,[31] his proposers described him as 'a gentleman of great merit, well versed in useful learning, & a Zealous promoter of various of the pursuits in which the royal Society interests itself'. Such zeal evidently proved enduring and nearly thirty years later 'Bootle, R. Wilbraham, Esq. MP' was listed amongst the names of those supporting the 1789 publication of General Arthur Phillip's account of his voyage to Botany Bay in Australia. With a poetic preface by Erasmus Darwin, the book's title page featured an engraved vignette of Josiah Wedgwood's 'Sydney Cove' medallion.

23. Black basalt bust of William Shakespeare presented by Josiah Wedgwood to Richard and Mary Wilbraham Bootle in c. 1771. 'JW' embossed on reverse of pedestal (height 15 ½ in, 39 cm).

The Wilbraham Bootles and Wedgwood

By then the Wilbraham Bootles were well acquainted with the pottery of Wedgwood & Bentley, having visited the factory at Etruria in north Staffordshire shortly after inheriting Rode in 1770. There, the family was able to see Wedgwood's much sought after Neo-classical ornamental wares: vases and busts in black basalt and jasper, inspired by the ancient Greek and Roman pottery of Sir William Hamilton, Britain's ambassador to

Naples. Writing to Bentley at Great Newport Street on 10 August 1771, Wedgwood seemed to have been as impressed with the younger members of the Wilbraham Bootle family as he was with their parents' commissions, commenting:

> Mr and Mrs Wilbraham Bootle were here a few days since, they seem'd vastly pleased & were very civil & polite, three or four of his Daughters accompanied them, & fine Lasses they are. I am to dine with them next week at Rhode & see what ornaments will be suitable for a bookcase there.[32]

The bookcase the Wilbraham Bootles had in mind was most probably the mahogany breakfront design from Thomas Chippendale, the foremost furniture designer of Georgian times. Now surmounted by a Cauldon vase decorated in Limoges Enamels by T. J. Bott, the bookcase displays porcelain on the first floor at Rode. However, in the late eighteenth century it would have furnished the old library on the ground floor. By then libraries were evolving into grander, public rooms, where gentlemen could display their books, paintings and collections of antique art, the spoils of their Grand Tours and material manifestations of their learning and good taste. Neo-classical busts became especially popular decoration for the tops of library bookcases, with English writers and poets deemed especially appropriate subjects.

The black basalt bust of Shakespeare (Fig. 23), which accompanies the numerous plaster casts and papier-mâché heads in today's library at

24. Wedgwood cream ware ('Queen's Ware') plates; left, feather-edged plate with brown transfer print of 'Liverpool birds', c.1770, and, right, Queen's shaped plate with black transfer print of 'Diana and her Hounds', c.1780. Standard-impressed Wedgwood mark (diameter 10 in, 25 cm).

25. Pair of delftware bottles or flasks with Chinoiserie-style decoration, probably made in Liverpool, c.1755 (height 10 in, 25 cm).

Rode, is almost certainly that selected by Wedgwood for the Wilbraham Bootles' bookcase. Thought to be made from a cast supplied by the London statuary of John Cheere (1709–87),[33] the bust is impressed with a rare 'J.W.' mark on its reverse, suggesting that Josiah Wedgwood might have presented it as a personal present to the family following their meeting. The potter remained eager to maintain his friendship with the Wilbraham Bootles, writing to Bentley on 30 July 1773: 'On Friday I went to pay a visit to Mr Wilbraham Bootle from whom I had rec.d a very obliging note – but he had gone to Knutsford Races.'[34]

It was probably during the 1770s–80s that Mrs Bootle also acquired the pair of Wedgwood cream ware plates remaining at Rode. Whilst the Queen's Shape design shows the huntress Diana and her hounds, the other feather-edged plate bears the pattern known as 'Liverpool birds', a name alluding to its printed decoration by Sadler & Green of Liverpool (Fig. 24). It was an appropriate choice for Mrs Bootle, for it was in Liverpool that her uncle, Sir Thomas Bootle, had first become known some fifty years beforehand.

Sir Thomas Bootle in Liverpool

Sir Thomas Bootle (1685–1753), or 'Bright' Bootle, as his rival Horace Walpole dubbed him, had been a figure of some significance during the second quarter of the eighteenth century when he maintained highly successful careers in law and parliament. Appointed King's Counsel by 1726, he was able to charge twelve guineas a day as a Chancery lawyer representing such clients as Sarah, Duchess of Marlborough, the 11th Earl of Derby and the 'proud' Duke of Somerset. Bootle's clientele reflected his adherence to the Whig opposition and it was on that platform that in 1724 he was elected Member of Parliament for Liverpool (where he also served as mayor in 1726) and, from 1734, for Midhurst in Sussex. Knighted in 1742, he served as Chancellor to both Frederick, Prince of Wales from 1740–51, and his successor, George, Prince of Wales.[35]

Sir Thomas Bootle's career in London inevitably kept him from spending much time at his country seat, Lathom, whose improvements he had overseen during the years he served as MP for Liverpool. From there, Sir Thomas had been well placed to observe the growth of Liverpool which, following improvements to its docks, continued to develop into one of the most important maritime ports in the country, with trade routes to Ireland and the Americas, Europe, Africa, the West Indies and later India and China. With better inland transportation, manufactured goods and raw materials poured into the city from the Midlands and the north of England: coal and later cotton came from Lancashire, salt from Cheshire, metals from the Midlands and, of course, pottery from Staffordshire.

Predictably, Liverpool lost little time in developing its own pottery industry. By 1710, the first of numerous delftware factories (Fig. 26) had been established, producing 'all sorts of white and painted pots and other vessels and Tiles in imitation of China, both for inland and outland Trade.'[36] A speciality of delftware was the large punch bowl made in a wide variety of blue and white or polychrome decoration. Ships were typical subjects, reflecting the popularity of the spicy alcoholic drink amongst merchant seamen, but landscapes, portraits and flowers were also favoured, often incorporating a motto or other inscription commemorating a current social or political event.

One of the most important early examples of political commemorative delftware is the punch bowl and cover made in Liverpool to celebrate Thomas Bootle's election as MP in 1724. Now in the Fitzwilliam Museum, Cambridge,[37] this elaborate item comprises a footed bowl and a tri-part lid incorporating two smaller bowls, perhaps for spices and fruit. Inscriptions include the arms and motto of Liverpool and 'THOMAS BOOTLE ESQUIRE MEMBER OF PARLIAMENT FOR

26. Delftware punch bowl and cover, made in Liverpool to commemorate Thomas Bootle's election to parliament in 1724 (height 23 in, 59 cm). (Fitzwilliam Museum, Cambridge)

27. A rare William Reid of Liverpool teapot, small sized and painted with a Chinese figure at a table with vases of flowers, beneath an overhanging tree, c.1756–58 (height 4 ¼ in, 12 cm).

LIVERPOOLE 1724' (Fig. 26). After two previous unsuccessful electoral attempts, Bootle's victory in Liverpool was an important one. It is not known whether he commissioned the commemorative punch bowl himself or if it was presented to him, perhaps by wealthy Lancashire landowners amongst his supporters.[38]

The chinoiserie style decoration of Thomas Bootle's delftware punch bowl was also adopted by the soft-paste porcelain factories which developed in Liverpool during the mid-1750s. Examples of their wares are represented in recent acquisitions to the teapot collection at Rode. Of these numerous interrelated ventures, the earliest is thought to have been Richard Chaffers & Co which in c.1756 began production of soapstone porcelain of the Worcester type. When Chaffers died in 1765, one of his partners, Philip Christian, used the same ingredients to continue production at Shaw's Brow of a wide range of oriental and European designs, either underglaze blue painted or enamelled. A partner of both Chaffers and Christian was James Pennington, the eldest of three brothers whose various collaborations produced mostly teawares at five different factories over a period of some forty years. James Pennington was also the last of three potters to manage the factory of William Reid

(Fig. 27). Operating from c.1755 until c.1772, Reid's was the largest and most technically consummate of all the Liverpool works, having been built especially for the manufacture of porcelain.

The Liverpool porcelains and Sir Thomas Bootle's earlier delftware bowl exemplifies the cross-cultural exchange of ideas and designs which increased maritime trade had brought to the country. Instrumental in this process was the English East India Company whose vast cargoes of Chinese porcelain were shipped over by men such as Mrs Bootle's father, Captain Robert Bootle (c.1708–58).

Captain Robert Bootle of the Honourable East India Company

By the early 1700s, a little over one hundred years after its founding, England's Honourable East India Company had seen off foreign rivals and native 'interlopers' to gain dominance of inter-Asian maritime trade. Already bringing pepper from Java (now Indonesia) and textiles from the Mughal Empire of India, by the beginning of the eighteenth century the company was also trading directly with China, whose luxuries included fans, cabinets and screens, painted wallpapers, silk, tea and porcelain. Apart from silver and fine woollen textiles, the English goods it offered in return were few: metals and sundry articles such as watches, clocks, spectacles, mirrors and firearms, and also materials it acquired en route for re-export. Nonetheless, the company grew to become the largest the world has known, wielding immense commercial and political power.

One reason for the mercantile success of this complex and sophisticated organisation was the fusion of its own interests with certain of its employees who were allocated a percentage of their ship's tonnage to transport their own goods to and from Asian ports. Although the company paid a relatively modest salary and also levied a fifteen per cent commission on sales through its compulsory East India House auctions, 'Private Trade' nonetheless provided a lucrative business which enabled it to recruit the very best staff. During the first quarter of the eighteenth century, a ship's captain could reasonably expect to see his annual salary of £120 increase thirty-fold as a private trader. Indeed, it was estimated that the profits from just one voyage to China allowed him to live comfortably for the rest of his life. As commander of his own ship, Captain Robert Bootle was to make two such voyages.

Bootle's career with the East India Company began in c.1720–21 as 1st mate on the Frances. Two years later, he was captain of his own ship, the London, a 490-ton, ninety-eight-crew, thirty-two-gun 'East Indiaman'. It is likely that he part-owned the London, with his brother, Sir Thomas, and a number of other wealthy shareholders, as it was usual for the company to hire its ships from syndicates. As commander, Captain Bootle's job was to employ its crew and get the London to and

from its destination swiftly and safely, avoiding the usual perils of disease, shipwreck and piracy.

Indiamen sailed only every other year and between 1723 and 1732 the London was to make three voyages to India and St Helena in the South Atlantic Ocean before the two she made to China. The London's log books, which still survive amongst East India Company records, provide a fascinating record of these voyages under Captain Bootle's command. The first to China began on 23 January 1735 when the ship sailed out of Plymouth Downs with a cargo consisting mainly of silver and 'broad cloth' with additional chests of treasure providing gratuity for the ship's company 'in case of being attacked by Europe Pyrates or any other enemy.'[39] Stopping for two weeks in May in Batavia (now Jakarta), the London finally arrived in China on 25 July, anchoring in Whampoa, a few miles below Canton on the Pearl river. Staying until the end of the trading season at Canton (then the company's sole trading post in China), Captain Bootle's three supercargoes, Richard Newnam, Richard Moreton and Isaac Houssaye, set about completing their business with the foreign wholesale factories or 'hongs'.

28. Extract from the private trade list of Captain Robert Bootle, recording the chinaware he brought back from his second voyage to Canton in 1737–38 (By Permission of The British Library, Oriental and India Office Collections, G/12/44).

Although porcelain constituted less than ten per cent of its total trade with China, the quantities imported by the East India Company were nonetheless immense; from 1730 until the end of the century, the annual figure was some 517,000 individual pieces. Not only was porcelain a good cheap commodity providing the company with a modest profit, it also served as a waterproof, non-polluting flooring for its more precious and lucrative cargoes of tea and silk. The main manufacturing area for export porcelain was Jingdezhen on the banks of the Chang river in the southern Chinese province of Jiangxi, over 400 miles from Canton. There, skilled and versatile Chinese craftsmen were able to produce large quantities of porcelain specifically for European taste. If not copying directly from a ceramic model, shapes might be reproduced from wooden, silver, pewter or glass prototypes whilst patterns could be readily copied from engravings, paintings or sketched designs. The huge bulk of porcelain which the East India Company bought on its own account was tableware. By limiting its decoration to a few patterns, either blue and white or enamelled in colours, vast quantities of items could be made up into services and sold on to England's coffee-houses, hotels and domestic households.

In October 1735, 187 chests of such porcelain had been packed onto the London, perhaps in sago or third class tea. Negotiations for its purchase were made through a number of different wholesale traders at Canton dealing directly with Jingdezhen potteries. One trader, 'Leongua', supplied in excess of 40,000 items, agreeing to 'pay all Dutys and Charges, Chests accepted, and to allow 2 per cent for breakage.' Either 'blew & white' or 'enamel'd & Gold & Colours', his china included single plates; dishes and plates, 'in setts'; bowls, 'single and in nests'; 'sallad' dishes; and cups and saucers. By December, it was reported that 'the London had all her teas on board, except the Hyson and Bing Tea which we are now loading as fast as possible & the merchants promise us our silks in 6 or 8 days, that we hope to get from here by the 10th Jan.'

Its business thus done, the London finally arrived in England in August 1736. Back at his Hatton Garden home in London, Captain Bootle was reunited with his wife, Ann, and infant daughter, Mary, but it was to be a brief respite. In February of 1737, the London set sail for China again, loaded with bags of silver, pigs of lead, bales of cloth and chests of treasure. Advancing '1 bag of silver upon Account of China Ware' to Cantonese china traders, Souqua, Chetqua, Juqua and Felix, the ship loaded its cargoes of silks and teas and returned home in July 1738, this time via St Helena, 'there to deliver to the Governor and Council the Goods on board your Ship for the use of the said Island and after staying a proper time for the refreshment of your Ship's Company you are to make the best of your way for the Port of London.'

The London's log books indicate that Captain Bootle was not only an energetic and successful commander of his voyages but also an astute private trader.[40] (Fig. 28) Like his contemporaries, he would have been allocated some thirteen tons or five per cent of the London's total cargo weight during its voyages to China. In order to maximise profits, it was necessary to include a number of high-value items amongst this limited cargo; thus, two thirds of Captain Bootle's entire private trade was gold, which he most probably exchanged for silver at favourable rates, with the remainder consisting of tea and porcelain plus a wide variety of luxury goods. From two trips to Batavia, Captain Bootle purchased eighty peculs of sago, a lacquered table and boxes, 19,000 walking canes and thirty-five leagers of arrack, a strong liquor possibly destined for Sir Thomas Bootle's delftware punchbowl! His cargoes from Canton reflected England's enthusiasm for all things Chinese: assorted damasks and silks; tubs and chests of teas; gold lamps and lacquer work; rosewood furniture and painted wallpaper; fans and handkerchiefs; glass pictures and copper engravings; exotic shells and cinnabar; rice and rhubarb; musk and aloes; bundles of rattan; china root – and porcelain.

Although examples of less expensive blue-and-white Chinese export porcelain may still be found in the cellars of some country houses, Rode included, it is the more carefully treasured decorative examples which survive today. Sensibly, Captain Bootle brought back both sorts: large quantities of common chinaware, to be sold at East India auctions to London chinamen and other wholesale dealers, and a smaller number of costlier items, either for himself or ordered by friends and family. Of the private cargo of £2,880[41] brought back from his first voyage, there was £372 worth of 'Chinaware in Bundles' including 16,000 'coarse' teacups and 7,400 tea plates, plus '26,000 cups & scrs, blew & white'. His second journey to Canton followed the same pattern, his personal cargo including many thousands of beakers, teacups and saucers and plates, as well as hundreds of sauce boats, tea sets and dishes. Hidden away in the lists are more interesting items, a large enamelled jar, two large water cisterns, two stools and '4 Eagles in China Ware', as well as various sets of higher valued tablewares.

Captain Robert Bootle's second sailing to China was his last voyage. From 1740, the London was captained by his brother, Matthew Bootle, previously employed as its purser. Unfortunately, his captaincy was not to last long as he died, probably at sea, in 1745. By that time, Captain Bootle had been elected by his fellow shareholders in the East India Company as one of its twenty-four directors, a position he held during the years 1741–49 and again in 1752, 1753 and 1755. Two years later he accepted another election, that of Fellow of the Royal Society: 'a gentleman well versed in Mathematical learning, & several other branches of polite literature; having in the course of his travels made many judicious observations relating to natural knowledg [sic].'[42]

Amongst his illustrious proposers was Emanuel da Costa, a Portuguese naturalist and botanist who had undertaken research to manufacture soft-paste porcelain from Cornish soapstone.

The Bootle Chinese armorial services

The more costly 'enamel'd' domestic porcelain amongst Captain Bootle's private trade may have included one or more of the armorial services commissioned by the Bootle family, examples of which have been acquired for the Rode collection. A Chinese porcelain service bearing the coat of arms of one's family was a certain sign of status during the eighteenth century; from 1720 until 1780 some 6,000 services were specially made in China – more than one a week – for the wealthy aristocracy and gentry in England. Two decades before demand peaked in the 1750s, Sir Thomas and Captain Robert Bootle commissioned a total

29. Chinese porcelain mug from the armorial service made for Sir Thomas Bootle in c.1730, elaborately decorated with the Bootle coat-of-arms within a circular panel, unusual 'embroidered' scrolling gilding with flowers and green parrots, and *famille rose* panels with the Bootle crest and cypher 'TB' (height 5 ¼ in, 13 cm).

of four different armorial porcelain services. The Bootles are believed to be only the fourth Lancashire family to have ordered such services before c.1730.

The Bootles' armorial porcelain would have been brought back either on the London or on a friend's ship the following year, such pieces taking some while to decorate. Usually, Chinese potters and painters reproduced the latest shapes and border patterns from European designs, incorporating individual enamelled designs for coats of arms and crests copied from sketches or engraved bookplates. The Bootle arms were relatively easy – a chevron between three combs, suggesting a connection with the Lancashire textile trade, and a crest of a demi lion rampant holding an antique oval shield. Inevitably, mistakes were made in reproducing such a coat of arms and examples from the Bootle

30. Chinese porcelain dish from a *Famille Rose* armorial service made for Captain Robert Bootle. The arms, Bootle impaling Tooke, suggest the service was made on the occasion of his marriage in c.1730 (diameter 12 ¼ in, 31 cm).

31. Chinese porcelain dish from an armorial service made for Captain Robert Bootle, with blue enamel and *Bianco-sopra-Bianco* border decoration, c.1737 (diameter 9 in, 23 cm).

services, though very finely executed, show evidence of the frequent inconsistencies in the Chinese colouring of heraldic tinctures.

Sir Thomas Bootle's armorial service was decorated with an elaborately gilded scroll band border, a style signifying a date of c.1730 during the reign of the Emperor Yongzheng (1723–35). Within the scrollwork pattern (perhaps inspired by an eastern textile), distinctive parrots were enamelled in olive green whilst cartouches with *famille rose* borders contained the family crest and Sir Thomas's 'T.B.' cypher.[43] The pattern's unusual and unique design suggests an artistic trait, either in the Bootle family, the London's supercargo who obtained the service, or possibly the Chinese merchant or potter. Examples from Sir Thomas Bootle's original service now at Rode include a dish, a mug (Fig. 29) and a rare enamelled copper, domed meat cover of c.1730. Between the years c.1723–30, similar domed-shaped covers were made of porcelain for some six very grand armorial services. Produced in four sizes, the porcelain covers were designed to sit on a dish but their heavy and somewhat clumsy design proved short-lived. It is possible that the Bootles suggested a more practical alternative when ordering their beautifully decorated copper cover but this, too, was superseded in c.1732 with the introduction of the first Chinese porcelain tureen and cover made after

32. Derby porcelain tea bowl, an example of the armorial teawares commissioned by Mrs Bootle during the 1780s to 'match' Sir Thomas Bootle's earlier Chinese armorial porcelain. Incised 'N' mark (height 2 in, 5 cm).

silver shapes. The Bootle armorial service is probably unique in including a domed meat cover in copper.

At around the same time that Sir Thomas Bootle's porcelain was made, Captain Robert Bootle ordered his first armorial service, its diaper border placing it stylistically during the Yongzheng reign (1723–35). The dinner service was most probably commissioned on his marriage to Ann (née Tooke of Kent), as its arms are of Bootle impaling Tooke, which depict three griffins' heads (Fig. 30). A coffee service with the same design and style of arms but with additional blue enamel decoration was possibly ordered at the same time, c.1730. Some years later, in the early years of Qianlong's reign (c.1736–95), yet another dinner service was commissioned, decorated with the Bootle Achievement in a distinctive white enamelled *Bianco-sopra-Bianco* border (Fig. 31). Examples from both dinner services are displayed at Rode.

Mary Bootle grew up dining from her family's Chinese armorial porcelain and treasured the patterns enough to place orders for additional and replacement pieces later in the century. She ordered dinnerware items direct from China, probably in the 1790s when new shapes such as a dragon handled mug, a cider jug with a cross strap handle and oval plates were available. Later examples may be distinguished by a slight difference in colour, with the parrots in Sir Thomas Bootle's original pattern enamelled in turquoise rather than their original olive green.

Whilst Mrs Bootle's armorial dinner wares were matched in China, she ordered teawares 'with Arms to match' from Derby. Founded in c.1750, Derby was then arguably the most prestigious of England's porcelain factories, its former proprietor William Duesbury I having acquired the Chelsea factory in 1770 and run it in tandem with his own

works until 1784. Surviving company archives reveal that Mrs Bootle was an enthusiastic customer and provide some information on her acquisitions during the mid- to late 1780s.[44] In common with other members of the aristocracy and gentry, she usually placed her orders at the company's London showroom, Mess. Duesbury & Co, in Bedford Street, Covent Garden, or received its manager, Joseph Lygo, at her Bloomsbury Square townhouse.

In a letter from Lygo to Duesbury II dated 20 December 1787 it was stated that 'Mrs Bootle… is going to have some dishes made to match some foreign China which can be done very well, have done the same pattern before in Tea China with arms &c.' Subsequent letters confirmed that although the decoration of the teawares was to be the same as the Chinese originals:

> … the pieces of Tea China she wants made, will not go to the expense of having the embossd work modeled therefore desires you will form the pieces wanted on plain ware as near to the shapes and Sizes as you can conveniently, and enameld to match the patterns sent, (the tea pot is to be our last new shape and Size). Mrs B will not at present have any plates to match but desires you will return the pattern as soon as you can spare them as they belong to a Set used in Town. I am desired to wait on her in the morning again.

An unhandled tea bowl (Fig. 32) is the only example in the Rode Collection of the earlier Derby armorial tea wares made for Mrs Bootle but the surviving Day Books from Derby's London showroom record

33. Worcester porcelain teapot of globular fluted form with a matching hexagonal fluted teapot stand, decorated with a rare enamelled and gilt Chinese-style pattern sometimes called the 'tent pattern', c.1758 (height of teapot 6 in, 15 cm).

her subsequent orders: '23 May 1787, Sold Mrs Bootle, 2 Cream Ewers with Arms to match £1 0s 0d, 2 Tea pot Covers ditto £0 8s 0d' and '6 April 1789, Sold to Mrs Bootle, 6 Coffee Cups enam'd with Arms to match £2 8s 0d, 3 Chocolate Cups ditto £1 7s 0d, 1 Tea pot Cover enam'd to match £0 2s 6d, 1 Full size Tea pot ditto £0 10s 6d.'

Eighteenth-century tea wares

Although Charles II and his Portuguese wife, Catherine of Braganza, had popularised tea during the 1660s, it was not until the Honourable East India Company started trading in Canton that the English aristocracy turned the drink into a declaration of refined taste and politeness. Inevitably, the gentry and the 'middling sort' also took up the exotic and healthy alternative to alcohol, water then being mostly unfit to drink, and following the reduction of import duty in 1784, tea finally became affordable to all levels of English society.

During the 1730s Captain Bootle had brought back a number of different tea varieties in his private trade allowance, including Hyson, a green tea, and Bohea and Congou, different grades of more popular black teas. On his first voyage, he also purchased '1 small basket inclosing Bohea Tea' and '2 large Canisters'. Each described as 'a present', they may have been intended for his young wife, Ann, whose will of 1767 specified that 'all my diamonds, watch, gold chains and rings, tea cannesters & flat candlesticks to be divided as my Daughter [Mary] think proper...'[45]

At that time it was usual to find a porcelain tea canister, a covered storage pot, in the elegant and essential 'tea equipage' which pottery and porcelain manufacturers had developed in response to tea drinking in Europe. The standard composition of a complete Chinese tea service

34. Left, extremely rare Chelsea porcelain octagonal cream boat, with a flat scroll handle, finely painted in the Meissen-style with European figures, chocolate-brown rim, c.1751 (height 2 ¼ in, 5.7 cm); right, Worcester porcelain 'High Chelsea ewer' cream jug, with exotic or 'fancy' bird decoration from the Giles workshop, c.1770 (height 3 ½ in, 8.9 cm).

was described in the list of Captain Bootle's East India Company cargo which included '150 setts for Tea Table, Blue & White, each containing 12 cups, 12 saucers, 1 sugar dish & plate, 1 slop basin & plate, 1 Tea Pott and Square, 1 Milk Pott, 1 Canister & 6 Cups with handles.' (Figs. 33–34). The specification 'with handles' was important at a time when most of the less expensive services followed the oriental fashion for tea bowls without handles.

Coffee, first introduced to England from Mocha in Yemen in the seventeenth century, continued to be popular throughout the 1700s and it was convivial coffee-houses which first served tea to gentlemen; Mrs Bootle regularly settled her younger son's 'Coffee House Bill for Tea', that from Sept 20th to Dec 1st 1788 costing her £1-5s-6d.[46] Although complete 'coffee equipages' were produced, a tea service might also have included coffee cups or cans, a cream ewer and, very occasionally, a coffee pot (Fig. 35). A communal spoon tray was a rarer addition to the tea service.

Chocolate, which became a fashionable social drink at the same time as tea, was sipped from tall, sometimes covered cups with either one or two handles. Recognising their market appeal, Captain Bootle's 1735 private cargo had included '100 chocolate cups & scrs & small

35. Worcester porcelain covered tea- and coffee pots painted in colours with variations of the Chinese-derived 'Black Quail' pattern. Teapot, left, with iron red and gold border, c.1770 (height 5 ½ in, 14 cm); and rare coffee pot, right, said to have been presented to the Sylvester family of Worcester by Dr Wall, c.1770 (height 9 in, 23 cm).

bowls'. Some seventy years later, 'Mrs W B' was making regular payments to 'Mackay, Gilman & Antrobus for chocolate £4-0s-6d'; to 'Mr Antrobus £4-4s-0d for coffee'; and again to 'Mr Antrobus Tea Man £10-10s-0d'. In 1808, one year's supply of all three drinks amounted to £34-9s-0d. 'Caudle', the spicy gruel favoured by invalids and nursing mothers, does not feature in family accounts although as the eighteenth century progressed it was popular enough to warrant its own receptacle. Similar in shape to a chocolate cup, the often finely potted and beautifully decorated 'caudle cup' was more accurately described as a 'cabinet cup', in acknowledgement that many domestic table wares were intended for ornament rather than utility. This is nowhere better illustrated than in Rode's outstanding collection of Chelsea and Worcester Giles-decorated tea wares (Figs. 36–37).

36. A very fine Chelsea teapot in the rococo style, with elaborately moulded handle, spout and openwork spherical finial to the cover. Moulded and gilded panels are painted with swags of coloured flowers and the rare claret ground has *ciselé* gilding with birds and insects amongst fruit and foliage, c.1760. Gold Anchor mark (height 5 ½ in, 14 cm).

Although tea was more expensive than coffee and chocolate, it soon became the most popular beverage of the eighteenth century. Although initially taken after dinner at around five o'clock, it was soon consumed, with some sweet confectionary, at all times of the day, in both public places, such as the Ranelagh gardens in Chelsea frequented by Mrs Bootle,[47] and in private households. At home, the civilising ceremony of taking tea enabled Georgian aristocracy and the aspiring middle classes to display their newly acquired porcelain alongside yet more accessories developed by entrepreneurial manufacturers: lockable tea chests; tea trays, tea caddies and tea tables. Valuable silver tea wares included tea-kettles and later urns for boiling water; tea- and coffee pots, developed

in the seventeenth century from imported porcelain precedents; sugar basins, tongs and 'nips'; milk jugs; creamers; and teaspoons, all of which might be engraved with the family coat of arms.

The increasingly popular custom of visiting allowed the lady of the house to preside over the tea ceremony, simultaneously indulging in a little social chitchat or scandal. The French femme de lettres, Madame du Bocage, reported taking tea at Mrs Montagu's in 1750 'in a closet lined with painted paper of Pekin, and furnished with the choicest movables of China. A long table, covered with the finest linen, presented to the view a thousand glittering cups, which contained coffee, chocolate, biscuits, cream, butter, toasts, and exquisite tea. You must understand that there is no good tea to be had anywhere but in London.'[48]

Mrs Bootle certainly entertained guests to tea at her Bloomsbury Square home, using her Derby armorial porcelain amongst other tea wares. In the country, she may have used the Worcester tea service which

37. Tea- and coffee wares with exquisite decoration by the Giles atelier. Left and far right: coffee cups and saucers of similar patterns with uneven sea-green ground colour and reserve panels painted with naturalistic birds on branches, formal gilt flowers in smaller reserves, c.1768. Worcester's 'crossed swords and 9' mark in underglaze blue. Second left: tea bowl and saucer, richly gilt claret ground with heart-shaped reserves painted with a bird on a fruit spray, Worcester, c.1770. Second right: tea bowl and saucer, gilt line edged, painted with exotic birds and foliage and a bunch of cherries in the base of the cup, Worcester, c.1765–70 (largest saucer diameter 5 in, 12.7 cm).

38. Items from the Worcester porcelain tea service: a tea bowl and a tea cup and saucer to the foreground, and, behind, a 'sparrow beak' milk jug, sugar bowl and teapot, all with covers with flower finials. The Sèvres-style *Feuille-de-Choux* pattern has shell-shaped panels with blue-feathered and gilded scalloped edges enclosing painted flower sprays, c.1760 (height of teapot 6 in, 15 cm).

has survived at Rode, its delicate, gilded *Feuille-de-Choux* pattern typical of the Sèvres-style designs produced by that factory from the mid-1760s (Fig. 38). It is not known whether Mrs Bootle purchased any Giles-decorated tea wares; a ledger from James Giles's last years of business does not include the family name in its list of élite customers but the limited period covered, 1771 to 1776, suggests that the record may be incomplete.

Derby archives show that Mrs Bootle purchased several teapots from the company during the 1780s, although the costly item noted in

39. Teapots displayed in the drawing room at Rode. The collection, amassed by Sir Richard Baker Wilbraham, represents the majority of the English porcelain factories producing enamelled decoration in the last half of the eighteenth century.

her own accounts when 'Wilbraham' left school, 'Mrs Grant a teapot £4-0-0', was probably silver. By then, tea wares were established as the staple product of English ceramics manufacturers and the teapot the key item in their repertoire (Fig. 39). During the late 1690s and early 1700s, the 'quality' had favoured teapots made from red stoneware, such as those produced by the Elers brothers, but the introduction of English porcelain created another alternative to the Chinese. Unfortunately, the delicate soft-paste of English porcelain lacked the heat resistance necessary for tea-making in England; boiling water from the silver tea kettle caused many teapots to crack, with early Derby models especially susceptible to fracture. Worcester, possessor of a superior soapstone body,

40. Two English porcelain covered teapots, both with enamelled Chinese-derived patterns and made in c.1756. Left, Derby teapot of lobed form with a moulded shell at the tip of the spout, the earliest identified Duesbury Derby shape (height 6 in, 15 cm), and an elegant Worcester teapot painted with a rare unrecorded Chinese pattern (height 5 ½ in, 14 cm).

41. The Worcester 'Stag Hunt' pattern, an oriental scene possibly sourced from a European engraving, finely painted in enamels in the scrolled mirror reserves of a rare leaf-moulded teapot and cover, c.1754–56 (height 7 ½ in, 19 cm).

42. An exceptional Longton Hall teapot with a perfectly spherical body, softly painted with European flowers, and an elaborate scroll-moulded handle and serpent spout. The almost flat cover has a moulded rosebud finial, c.1753–54 (height 4 in, 10 cm)

43. Two rare teapots painted with small tortoiseshell butterflies and bouquets of European flowers. Left, a small, oval covered teapot from Nicholas Crisp's factory at Vauxhall, c.1755–60 (height 4 ¼ in, 10.7 cm); and, right, a very fine globular-shaped Worcester teapot with mushroom finial to the cover, c.1756–57 (height 4 ¼ in, 12.5 cm).

was especially renowned for producing designs as efficient as they were elegant (Fig. 40). Hard-paste porcelains of the late 1760s and 1770s produced by the Bristol and Plymouth factories were also surprisingly prone to manufacturing faults, although techniques and recipes developed by the New Hall consortium in Staffordshire in the following decade finally rendered a hybrid paste more reliable.

Until the 1790s when an oval form of teapot became more prevalent, manufacturers mostly produced designs based on the globular-shaped body of the Chinese export teapot, the small size reflecting the expense of the tea. Within this standard form, much variety and even novelty could be expressed. Shapes might be hexagonal, octagonal,

relief-moulded, lobed, fluted, barrel-shape, reeded or 'silver-shape' (sometimes called 'commode shape'). Covers and knops, bases and stands, spouts and handles were all equally inventive as Chinese simplicity gave way to rococo flamboyance. Reflecting the source of their contents, the decoration of eighteenth-century teapots also initially paid homage to the Orient, with figures and flowers in a *famille rose* or *famille verte* palette; decorators subsequently copied or adapted Meissen and Sèvres-style patterns with reserves of European flowers and 'ombriete' insects, vivid ground colours and elaborate tooled gilding. This huge diversity of shape and decoration is demonstrated in the impressive collection of teapots at Rode, which represents the majority of the English porcelain factories producing enamelled decoration in the last half of the eighteenth century (Figs. 41–45).

Eighteenth-century dinner and dessert wares

A letter that Mrs Bootle wrote to Dr Loveday on 6 June 1793 reveals that she enjoyed entertaining her large family. She wrote: 'we celebrated our 38th Wedding day on Friday last the 31st of May when although we sat down 18 at dinner yet we had fewer of our descendants than usual.' Her disappointment at the small gathering contrasts with her delight in an event she organised five years later. Then, at the age of sixty four, Mrs Bootle invited to Lathom a party of 'very fine looking young men' she had helped recruit to the Ormskirk Volunteers, then off to quell the French-backed Irish Rebellion:

> ... many of these are my own outdoor servants; and Servants Sons: I gave them their Colors, and what was better, I gave them all a dinner in my own house to the number of 220; besides the friends I had with me on

44. Teapots from the west and east coasts of England: top, a hard-paste porcelain teapot from Champion's factory at Bristol, painted with a Chinoiserie-style pattern, c.1775–78. Painted Bristol cross mark and painter's numeral '7' (height 6 in, 15 cm); bottom, a soft-paste porcelain teapot from the Lowestoft factory, decorated in polychrome enamels with floral cornucopia in the style of Thomas Curtis, c.1785 (height 6 in, 15 cm).

45. A rare Worcester barrel-shaped teapot, with distinctive yellow-coloured ribbed bands, and a flush cover with a moulded flower finial, painted with flowers, flies and ladybirds and carmine monochrome decoration to the spout and handle, c.1770 (height 4 ¼ in, 10.8 cm).

the occasion, it was well conducted, and well received; two Bucks two Oxen and 8 sheep were killed upon the occasion, with a Hogshead of my strong Ale, and Sixty Gallons of Punch to wash them down; no wine appeard; I and my Company dined with them and we had a full band of regimental music playing all the time; after the first Toast which I stood up and gave, the King and Constitution. When the fine harmonious Strains of God Save the King sounded all over the house; a violent burst from the Hall echoed Mrs Bootle the Lady of Lathom for ever; this was drunk with a cheer of three times three; the Ladies withdrew and they sat singing songs and very joyous they were till 8 o clock; and then they all departed. I cannot say they marched back with the same Military exactness that they came...[49]

At a time of poor harvests and restricted food imports such generous hospitality would have been especially appreciated by the assembly. It is likely that Mrs Bootle would have provided pewter or earthenware on that occasion, wisely reserving porcelain, possibly Chinese, for her friends.

It was during the 1730s, when Mrs Bootle's father was shipping Chinese export porcelain to England, that individual items were first formalised into complete dinner services. These usually comprised two tureens, covers and stands, soup plates, various sized dishes and dinner plates, salad dishes and a salad bowl, two sauce boats and four salts. The Meissen factory was by then also making complete services, with that at Sèvres setting the fashion from the mid-eighteenth century

46. A pair of extremely rare Bow sauce boats, elaborately modelled with griffin head handles and floral swags after a 1752 silver shape by Charles Kaendler (the London-based half-brother of the celebrated Meissen modeller). Delicately painted with floral sprays and a puce-patterned inner border (height 7 in, 18 cm).

47. Large charger from the Bow factory, finely enamelled in the *famille rose* style with Chinese figures and a deer in a landscape and a floral border of peony sprays, c.1758–60 (height 12 in, 30 cm).

onwards. It is well known that the Prince of Wales, later Prince Regent, was to favour Sèvres porcelain (as well as English) although whether Mrs Bootle's antipathy to the French would have permitted her to do the same is arguable!

Most probably she would have followed the custom of service *à la Francaise*, allowing her guests to select their own food from an assortment of dishes laid out symmetrically on the dining table. In the second half of the eighteenth century, cookery writers such as Mrs Elizabeth Raffald gave guide lines to the aspiring middle classes on how to set their table in an elegant yet economic manner. In the grand houses of ladies such as Mrs Bootle, four courses were usual, served at around two o'clock: the first consisted of soups, fish, meats and vegetables; the second offered both savoury dishes of roast meat and fowl and sweet puddings; an intermediate course of cheese and salad followed; and, finally, with the removal of the precious damask linen table cloth, the dessert course, with its hot house fruits and preserves, creams and tarts, and wafers and biscuits.

From the 1750s English porcelain manufacturers produced a wide variety of dinnerware shapes, encouraging and responding to the new enthusiasm for formal dining. Oriental then continental porcelain inspired much design but silverware also provided a useful design source for ceramics modellers. A pair of elaborate sauce boats remaining at Rode are examples of fine modelling by the Bow factory which operated in London from c.1747–74 (Fig. 46). Based on a silver rococo model of 1752 by Charles Frederick Kaendler, the sauce boats have distinctive griffin-shaped handles and may have been acquired by Mrs Bootle, perhaps alluding to the Tooke family coat of arms which depicted three

48. Hexagonal-shaped Chelsea porcelain teapot, with the 'Flaming Tortoise' pattern copied from Japanese Kakiemon porcelain, c.1752–54 (height 5 in, 12.7 cm).

49. 'Two Quails', the most popular Kakiemon pattern, with enamelled iron red and blue birds amongst oriental plants including a gilded flowering prunus. Here it decorates a circular pierced basket by Bow, marked with impressed and painted numerals, c.1755; a Worcester 'High Chelsea ewer' of c.1760; and a fluted covered sugar bowl also by Worcester, with the underglaze blue-fretted square mark, c.1765 (diameter of basket 6 ¼ in, 15.8 cm).

griffins' heads. Interestingly, Bow's pre-eminent partner, Thomas Frye, who had taken out the first English patent for porcelain manufacture in 1744, was a neighbour of Mrs Bootle's widowed mother in Hatton Garden; Frye moved there in 1759, just a year after Captain Bootle had left his wife 'my Dwelling House with Coach House, Stables and Garden… with the use of All the Household ffurniture, Linnen, Plate… and China Ware (Except my Books, Medals and Casts)…'[50]

Although Rode's later acquisitions of Bow exemplify the factory's high-quality enamelled and elaborately gilt porcelains, the greater part of its production was ordinary blue and white tableware made from a bone ash body for a middle-class market. A preference for oriental-style patterns led this large and hugely successful factory to call itself 'New Canton' in recognition of its debt to export Chinese porcelain (Fig. 47). Bow was amongst a number of English porcelain manufacturers, including the popular and innovative Worcester works and the smaller, more prestigious Chelsea factory, which also made copies and adaptations of Japanese Kakiemon and Imari porcelains. These brightly enamelled and sometimes gilded wares had been imported into Europe from the late

50. A pair of important pierced baskets by Bow, decorated with an iron red-and-gilt-foliate border and leaf sprays, and a bouquet of flowers, a dragon fly and a caterpillar finely painted by James Welsh. (The additional leaf on the bowl to the left probably disguises a minor flaw in the porcelain.) Each marked with '5' in iron red, the number associated with Welsh, c.1758 (diameter 4 ¼ in, 10.7 cm).

1600s until c.1740. Early examples were especially desirable in mid-eighteenth century England where they became commonly known as 'old Japan'. Kakiemon motifs, such as the 'Two Quails' and 'Flaming Tortoise' patterns displayed at Rode, frequently decorated Japanese-inspired octagonal wares (Figs. 48–50).

It was Derby which later became especially associated with Japan patterns of the Imari style, and a dessert service in a 'blue and gold Japan pattern' is the earliest documented purchase by the Wilbraham Bootles from that factory. Now no longer in the family, the acquisition was made in 1781, not at Derby's showroom but at one of the proprietor's then annual spring sales of 'An elegant and extensive Assortment of Derby and Chelsea Porcelaine' held by 'Mess. Christie and Ansell, At their Great Room, Next Cumberland House, Pall Mall' in London. An annotated sales catalogue in Christie's Archive records that on Thursday 10 May, Day 1 of the sale, 'R W Bootle', presumably buying on behalf of his wife, paid £13 13s 0d for Lot 28:

> a complete dessert service, blue and gold Japan pattern, consisting of 24 plates, 2 large oval comports, 4 small ditto, 4 octagon ditto, 4 round ditto, 1 basket for the centre, and 1 pair cream bowls, covers, stands and spoons.

The service was made in the final few years of the Chelsea Derby period (1770–84), when useful table wares were beginning to take a

51. A rare 'Dr Wall' period Worcester plate decorated in the Japanese style, with striped birds on a branch with blossom, thought to be copied from Meissen (diameter 8 ¾ in, 22 cm).

52. A brown-rimmed fluted Chelsea saucer decorated in the Meissen style, with sprigs of flowers and an '*ombriete*' insect to the border, and a finely painted estuary vignette to the centre, c.1752–53 (height 4 ½ in, 11 cm).

larger share of the factory's output, and was probably pattern number 3, a gilded Kakiemon pattern based on an earlier Chelsea design. Over the next few years, Mrs Bootle went on to purchase additional dessert ware items in the pattern, including round scolloped dishes and comports, small and large oval comports and '12 Fluted rim Desert plates'. The bright enamel colours and rich gilding of this pattern would certainly have impressed guests, especially when dining by candlelight, either at Bloomsbury Square, at Lathom, or at Rode.[51]

Whilst Japanese porcelain was also copied by Meissen (Fig. 51), it was the German factory's own decorative patterns which exerted the greater influence on 1750s English porcelain. The most commonly imitated decoration was the painting in enamels of scattered cut flowers, usually 'Deutsche Blümen' (native German flowers) though sometimes 'Indianische Blümen' (oriental flowers). Landscape scenes with European figures, which originated at Meissen, became popular subjects, as did harbour scenes which inspired delicately painted views on Chelsea porcelain, some by William Duvivier (Fig. 52). Worcester and the Giles atelier derived a wide variety of techniques from Meissen, notably the factory's distinctive yellow ground and Giles's painting of 'fancy' and naturalistic birds, cut fruit and flower patterns and over-

53. A Worcester scalloped-edged plate with a rare and unusual shagreen ground. Its reserved rococo gilt scroll panels are painted with Ho-Ho birds and oriental plants in the Japanese Kakiemon style, c.1765–70 (diameter 7 ½ in, 19 cm).

glaze scale grounds, all exceptionally well represented in the collection at Rode (Figs. 53–54).

Worcester's underglaze blue grounds – powder blue, 'Mazarine' or wet blue, and its famous blue fish-scale – appeared from c.1765 with other colours following thereafter. A Worcester blue-scale dessert

54. Slop bowl and tea cup and saucer from a rare Worcester porcelain service. The yellow scale ground, derived from Meissen, is only seen with exotic birds, here painted in large rococo gilt-scrolled panels. Smaller panels are painted with butterflies and bugs, c.1765–70. All items with the 'crossed swords and 9' mark in underglaze blue (height of bowl 3 in, 7.6 cm).

55. A collection of Worcester 'Blue Scale' porcelain of the 'Dr Wall' period displayed in the staircase hall at Rode.

56. Two Worcester porcelain moulded cabbage-leaf or 'Dutch' jugs. That on the left, with a scroll handle and mask lip spout, has exceptionally fine decoration including an underglaze blue ground with *ciselé* gilding and reserve panels painted with colourful butterflies and exotic birds including a rare owl, c.1765–70. The jug on the right, an earlier model, was factory painted, possibly by its principal enameller, James Rogers, in c.1758 (height 8 ¼ in, 21 cm).

57. Two fluted rimmed dessert plates from the Worcester 'Blue Scale' service, decorated with blue scale ground with ciselé gilding and rococo mirror- and vase-shaped reserves painted in colours with flowers. The plate on the right shows the damage sustained following its twenty-six-year submergence in Rode's stew pond! Fretted square and crescent marks in underglaze blue (height 7 ¼ in, 19.6 cm).

service at Rode (Fig. 56) may have been acquired by Mrs Bootle during the 'Dr Wall' period of its manufacture (1751–83). Of the costly and elaborate 'Lord Craven' type, it was decorated with flowers and foliage in *ciselé* gilding on a blue-scale ground, with rococo mirror and vase-shaped reserves painted in colours with sprays of European flowers, including auriculas, to the centre. In 1934 this fine service was stolen, probably to order, during an audacious 'brace and bit' burglary at Rode. Fleeing, the thief dumped his loot but, fortunately, did not return to collect it. Twenty-six years later, by chance, the estate's woodman recovered it beneath six feet of water in Rode's stew pond. Not recognising its

58. One of a pair of rare rococo-shaped sauce boats from the Vauxhall porcelain factory, decorated with a *gros bleu* ground with gilding and reserve panel painting of exotic birds and a butterfly from the London workshop of James Giles, c.1763–64 (height 3 ½ in, 8.8 cm).

58. A pair of important Worcester bronze beaker-shaped vases with gilded underglaze blue ground and reserve panels finely painted with Sèvres-style exotic birds in a landscape, c.1775. Fretted square mark in underglaze blue (height 6 in, 15 cm).

60. Small Meissen-inspired tureens and covers, modelled in animal and bird form and painted in natural colours:; a rare duck tureen of exceptional quality, Bow, c.1755–58 (height 3 ½ in, 8.8 cm); two hare tureens, Chelsea c.1756 (height 3 ¼ in, 8.25 cm); and a pair of Chelsea partridge tureens with matched numbers on lids and bases, c.1752–55. Red Anchor mark (height 4 in, 10 cm)

worth, the woodman left the 'old crockery' outside for several more weeks before he thought to inform the family of his find: over a dozen dessert dishes, four lozenge-shaped dishes with fluted borders, an oval strapwork basket with applied rosettes, and an unusual reeded porringer. Although its immersion resulted in some deterioration of the enamel painting and gilding, the Worcester blue scale porcelain had certainly proved its resilience (Fig. 57).

In recent years, several exceptional pieces have been acquired to complement the dessert service: a pair of pierced baskets, a teapot, a pair of bronze beaker-shaped vases (Fig. 59) and a cabbage leaf-moulded mask jug (Fig. 56). Whilst the baskets are flower-painted, the rest have reserved panels painted with 'fancy birds' including an owl unusually

depicted on the mask jug. Between 1755 and 1762, James Rogers, Worcester's principal enameller, was mainly responsible for bird painting at Worcester, his formal style contrasting with the more spontaneous Meissen-inspired bird decoration of the Giles atelier (Fig. 58).

The Worcester factory's pliable, endurable paste enabled it to produce a variety of tableware shapes for decoration, including from the 1760s designs derived from Meissen and bearing an imitation of the German factory's mark. In the decade before, Nicholas Sprimont's Chelsea factory had continued to experiment with its soft white glassy body, adding bone-ash to the ingredients towards the end of the 1750s. Chelsea was by then amongst several factories already copying or adapting Meissen's small-scale porcelain figures and together with Bow and

61 Fruit-formed lidded tureens, imitating Meissen and painted in natural colours, c.1755. Far left, a pair of lemon tureens sitting on delicately modelled leaves and mixed flowers; left, a pair of simple lemon boxes with small leaf and bud-formed finials to lids, Chelsea, Red Anchor marks (height 3 ¼ in, 8.8 cm).

62. A Derby porcelain *epergne*, modelled as a kingfisher perched on shell-encrusted rocks and scallop-shells, painted in natural colours and gilded, c. 1763–64 (height 7 in, 18 cm).

63. (top, right) A Derby porcelain butter tub on three feet, complete with scalloped-rimmed stand and a cover with a fruit finial. Painted with damsons, butterflies and insects, c.1760 (diameter 4 in, 10 cm).

64. A pair of Worcester porcelain dishes, of moulded and veined mulberry leaf shape, each painted by James Rogers with a rose bouquet, a butterfly and an insect, c.1758 (length 7 in, 18 cm).

Longton Hall was also the principal reproducer of its zoomorphic or naturalistically modelled tableware: tureens in the shape of fish, partridges, ducks and hares (Fig. 60), or cauliflowers, asparagus, lemons and melons (Fig. 61). Several rare examples are amongst today's collection at Rode.

Tableware incorporating naturalistic decorative forms became increasingly popular; jugs, sauce boats, sweetmeat dishes, trays and stands, epergnes and elaborately modelled porcelain baskets might be

leaf-moulded or embellished with moulded flowers, leaves, branches or shells. Such porcelain became an intrinsic part of the upper-class English dessert table, which from the mid-eighteenth century imitated that favoured by the French court: a fanciful feast of confectionery, laid out as a formal garden, with miniature pavilions and *parterres* made of sugar, sometimes peopled with allegorical porcelain figures (imitating earlier sugar-paste models) and always placed with lusciously coloured dessert wares.

65. Below, a Worcester Giles-decorated oval pierced basket with flower-encrusted rustic twig handles, applied blue and red cornflower rosettes and fruit painted to the centre, c.1770 (length 8 ½ in, 21.5 cm).

66. Worcester porcelain scalloped-edged plates, moulded with sprays of rose-buds and leaves and painted in natural colours in the pattern known as 'Blind Earl'. The smaller plates, left and right, with rustic twig handles, were factory painted whilst the centre one was gilded and decorated with flowers in James Giles's workshop, c.1765 (diameter of largest 7 ½ in, 19 cm).

67. Two rare Bow botanical plates. Of octagonal shape with chocolate-brown line rims, they are beautifully painted with large sprays of irises, left, and peonies, right, and coloured butterflies and bugs, c.1758 (diameter 7 ¾ in, 19.8 cm).

Mrs Bootle's 'Botanical' wares: the Chelsea 'Hans Sloane' plates

The sweet concoctions and exotic fruits served for dessert, like the flowers and natural forms portrayed on their porcelain dishes (Figs. 63–66), demonstrated the growing interest in natural history engendered by increased maritime trade and global exploration. As botany and horticulture became more accessible to the general public in Britain, national gardens, such as the Chelsea Physic Garden and the Royal Botanic Gardens at Kew and Edinburgh, became popular places to view rare varieties of plants and flowers. Whilst gardening and florists' societies grew and nurserymen and seed growers exchanged species across the globe, the wealthy landowning classes set about employing their own gardeners, building conservatories and hot houses, and, under the later influence of the landscape gardener Humphry Repton (1752–1818), laying out new flower gardens.

Mrs Bootle, like many Georgian ladies, took a particular pleasure in her gardens though, unfortunately, her correspondence with Dr Loveday reveals little of her evident interest. In 1774 she sent him apples 'like Eves', describing experiments in growing American varieties of the fruit carried out by botanists such as 'Dr Fothergill, Indefatigable in what he undertakes'. Vegetable growing also interested her; in June of 1780 she wrote from Rode that 'to give you an idea of the Backwardness of the Season we have not tasted Beans or Pease as yet; the latter are only in flower; the former will be ready in a few days.'

No mention is made of the Red Books Repton supplied for both Rode in 1790 and Lathom in 1792[52] although Mrs Bootle mentioned one gardener 'that lived many years with us at Lathom, a very Clever Man, he went to Russia where he became Gardiner first to Prince Petempkin [sic] and afterwards to the Empress.'[53] This was William Gould (1735–1812) of Ormskirk, who is believed to have laid out

Lathom's gardens in the style of 'Capability' Brown before going to Russia in 1780 to gain his own fame and fortune as gardener to Prince Potemkin, the lover of Empress Catherine II.[54] Gould was to design several parks and gardens for the Prince, most notably the magnificent Taurida garden in St Petersburg; at his own home in the grounds, Gould entertained many of Europe's aristocracy, including in 1792 the Bootles' elder son, Edward, then visiting Russia as part of his Grand Tour. All of Gould's garden designs, first for the Prince and subsequently for Empress Catherine and Alexander I, were in the English landscape style. This fashion had first been promoted by the Empress, a noted anglophile, whose admiration was such that she had commissioned from Wedgwood in 1773 the famous 994-piece 'Green Frog' dinner service decorated with views of English landscapes.

Many of the 1,244 scenes reproduced on Wedgwood's 'Green Frog' service were taken from printed sources. Printed books with botanical illustrations also provided a source of design for manufacturers of ceramics (and other decorative materials such as wallpapers and textiles), simultaneously educating the British public about newly discovered flowers and exotic plants. Although Bow produced some early wares in the botanical style (Figs. 67–68), such as Rode's rare dessert plates depicting plants with named stems, Chelsea is believed to have been the first porcelain factory to adapt botanical illustrations in c.1755–56. Amongst its earliest printed sources were engravings of paintings by the German artist Georg Dionysius Ehret (1708–70). These were selected from Ehret's own publication, 'Plantae et Papiliones Rariores' (1748–59); from Dr Trew's 'Plantae Selectae' (1750–53); and from Philip Miller's 'Figures of Plants' (1755–56). In contrast with the botanical style of ceramic decoration which originated at Tournai in Belgium, whereby plants were accurately and scientifically copied in the centre of the plate and named on the reverse in Latin, Chelsea's

68. Two rare scalloped, chocolate-brown rimmed botanical plates from Bow. The large sprays of flowers are, unusually, named on their stems: 'Gloriosa', left, and 'Egg Nightshade', right, c.1755–58 (diameter 8 in, 20 cm).

enamelled plant studies were freely painted, expansive and flamboyant. The factory's more expressive style quickly became known as 'Hans Sloane' type decoration, as the Chelsea Physic Garden, where Philip Miller (1691–1771) was curator, was on land leased from Sir Hans Sloane.

Rode is fortunate in having twelve outstanding Chelsea 'Hans Sloane' dessert plates in its collection (Fig. 69). These are believed to have been acquired by the family at the time of their manufacture during the late 1750s or early 1760s. The lobed-shaped plates have plain brown enamel rims and are marked with Chelsea's Brown Anchor, indicating that although they were produced in the factory's early 'Gold Anchor' period (1758–69), they are more stylistically linked to earlier 'Red Anchor' (1752–58) 'botanical' wares. Sharing a predominantly pink and blue-green palette, the plates are finely painted with a variety of plant species introduced into European gardens in the eighteenth century: the American cowslip, dog's tooth violet, turks-cap lily, cathedral bells with a rosebud, dahlia, geranium, the Scarlet runner bean and the broad bean.[55] Small bugs and insects appear on some plates, doubtless covering tiny flaws in the porcelain.

As none of the enamelled plants on Rode's plates has been found to match any of the published engravings of Ehret's paintings (nor any other publication, so far), it is probable that the paintings were reproduced by enamellers directly from original designs rather than from printed reproductions. As the country's most distinguished botanical illustrator, Ehret then lived close to the Physic Garden in Chelsea,

69. Two of the 12 Chelsea 'Hans Sloane' botanical dessert plates at Rode. Of lobed shape, they are finely painted within a brown line rim with a broad bean plant, left, and Cathedral Bells and a rosebud, right, c.1760. Brown Anchor mark (diameter 8 ¼ in, 21 cm).

spending his summers travelling and recording rare plants and his winters in London, teaching flower painting to the wives and daughters of the aristocracy and gentry. It is tempting to speculate that the young Mary Bootle might have been amongst those attending his classes during the 1750s[56] as her father and Ehret were elected Fellows of the Royal Society in the same year, 1757.

'Much pleased with all her things': the Derby 'Billingsley' dessert service

> Mrs Bootle sent for me to wait on her on Saturday to pay her bill and gave me another commission – she paid her bill with a great deal of satisfaction – and much pleased with all her things.
>
> *Joseph Lygo, Derby's London showroom manager to company proprietor, William Duesbury II, 26 Nov 1788.*[57]

It has been suggested that during the 1780s Mrs Bootle ordered from the Derby porcelain factory a set of dessert plates to match the family's Chelsea 'Hans Sloane' plates. If so, her order might plausibly be that described in the later memoirs of one of Derby's gilders, Samuel Keys (1771–1850). Commenting that the factory's flower painting was, in c.1786–88, 'at a very low ebb', Keys wrote:

> ... When Mr Duesbury [II] had been here a short time, an order came for some plates to match a Chelsea plate with a single plant in a curious style from nature... Billingsley made the attempt with the instruction of

70. Two of the Derby porcelain 'botanical' dessert plates at Rode, commissioned by Mrs Bootle during the 1780s and matching earlier Chelsea 'Hans Sloane' plates. Of lobed shape with brown enamelled rims, those illustrated are painted with the everlasting broad-leaved sweet pea, left, and the ragweed, right. The plate on the right is marked with Derby's puce 'crossed baton' mark and the number '7' associated with William Billingsley; the small pink rose also denotes his signature style (diameter 8 ½ in, 21 cm).

[landscape artist, Zachariah] Boreman. He copied any garden or wild flowers that suited, and when the order was sent off it gave great satisfaction. This order was followed by others, and flower painting was raising in very high estimation. Single plants were then most fashionable...[58]

A convincing reason for linking Mrs Bootle to the order is the existence at Rode of a remarkable collection of Derby dessert plates (Fig. 70) which not only have the same lobed shape as the family's earlier Chelsea 'Hans Sloane' plates but very similar decoration, enamelled with brown rims and 'botanical' flowers or plants. Displayed together at Rode, some slight differences are discernible between the Chelsea and Derby plates; besides the variation in the porcelain body, the Derby plates have more yellow tones in the palette, are rather more densely enamelled, and are painted in a more naturalistic 'botanical' style, sometimes with butterflies. Nonetheless, it is hard not to assume that the Derby plates were made to 'match' the earlier Chelsea ones.

Now numbering twenty one, it is likely that there were originally twenty-four Derby plates, two sets of twelve. A fully documented order in one of Derby's surviving Day Books indicates that one set was part of a complete dessert service, 'enam'd with different plants & Brown edge', which was sold to Mrs Bootle on 25 June 1788. The service cost a total of £28 13s 0d, including 'Packing Case 2s 6d', and in addition to the '12 Desert Plates £5 5s 0d', comprised '4 Small Scolopd Bowls £2 10s 0d'; '4 Large Scollopd Bowls £3 12s 0d'; '1 pair of Double Ice pails £5 15s 6d'; '4 2nd size Oblong Comporteers £3 12s 0d'; '4 Large square Comporteers £4 4s 0d'; and '4 four Scollopd Comporteers £3 12s 0d.'

71. The Derby 'Billingsley' dessert service set out in the dining room at Rode (re-creation courtesy of Peter Brown).

This beautiful 'botanical' service also remains at Rode.⁵⁹ (Fig. 71) The set has survived almost intact, missing only two large scolloped bowls, one four-lobed dish or comport, and its original pair of ice pails (of which only the damaged covers remain).

The covered ice pails displayed with the service today are later replacements made by Spode (founded 1770), probably using moulds borrowed from Derby. Their manufacture was almost certainly requested by Mrs Bootles' son, Randle Wilbraham of Rode, when he visited Spode's factory in Stoke-upon-Trent in the company of the Prince Regent in 1806. One of the ice pails bears a rare bat-printed 'Prince of Wales' feathers' mark, which was used between c.1806–08 to commemorate the royal visit, whilst payment was probably included in the sum recorded in Randle Wilbraham's General Account book at Rode: 'May 8th 1807 Spode for China made at Stoke £18 10s 6d.' The ice pails are made of what is now called 'bone china', essentially a hard-paste porcelain of which forty per cent constitutes bone ash. Perfection of this new ceramic body is credited to Josiah Spode I and, interestingly, the earliest known reference to it is his invoice, dated 9 July 1796, to 'Wm Tatton' of Tatton Park, otherwise known as William Egerton, Mrs Bootle's son-in-law. Coincidentally, the invoice also includes 'A Botanical Desert Sett Compleat Blue Enamelled Border & Burned Gold Edge' with '2 ice pails to match.'

In addition to a sporadic puce-painted Derby factory mark (1784–1806), a number of items in Rode's Derby porcelain dessert service also have a 'long-tailed 7' painted in the same colour or in red (Figs. 72–74). This was the number used by William Billingsley (1758–1828), then Derby's leading flower painter, and the artist Keys identifies as

72. Comports from the Derby 'Billingsley' dessert service, both with the factory's puce 'crossed baton' mark and the painter William Billingsley's number '7' in puce, c.1787–88. Left, a lozenge shape, painted with a yellow tree lupin, red currant and rosebay willow herb (length 10 ½ in, 26 cm); and, right, a four-lobed shape decorated with plush anemone, lily of the valley and nasturtium (length 9 ½ in, 24 cm)

painting the 'Chelsea replacement' plates. The dessert service at Rode is the largest and most complete surviving service decorated by Billingsley who today retains his reputation as one of Derby's most accomplished and innovative flower painters. Especially renowned for his depiction of roses and the technique he pioneered of wiping out highlights with his brush, Billingsley's talents were doubtless encouraged by his father. He, too, had been a flower painter at Chelsea during the mid-1750s when 'Hans Sloane' plates were first manufactured.

Before leaving to co-found the Pinxton china works in 1795, Billingsley Junior spent a total of twenty-one years at Derby. His apprenticeship started in 1774 when he learnt to paint posies and stylised groups of flowers in the manner prevalent during the Chelsea-Derby period (1770–84). Later, in the mid-1780s, he adapted to formal floral designs and borders, before the order to 'match a Chelsea plate' in c.1786–88 heralded a more 'naturalistic' interpretation of the 'botanical' style of painting either single or grouped specimens. The trend of accurately depicting, from a printed source, a single plant or flower which was usually named on the back, was finally launched by Derby in 1791, with its first recorded sale of a botanical service to the Prince of Wales.[60]

73. Two lobed square-shaped comports from the Derby 'Billingsley' dessert service, both with the factory's 'crossed baton' mark and William Billingsley's number '7' in puce, c.1787–88 (diameter ¾ in, 2 cm). That on the left is decorated with variegated tulips, double pink larkspur and ranunculus, and that on the right with a spray of pink roses, a yellow tree lupin and redshank.

Billingsley's naturalistic 'botanical' style, as exemplified in the Derby plates and dessert service at Rode, represents an important transitional phase in the history of the company's flower-painting. Key's description of his 'curious style after nature' implies that Billingsley did not use printed sources and indeed none has been identified for the dessert wares at Rode.[61] Although Mrs Bootle ordered her service in 1787, the year England's first botanical journal, Curtis's *Botanical Magazine*, was published, it was not until c.1791 that the Derby factory acquired copies, together with Sowerby's *English Botany*, to use as source material for subsequent botanical services. It seems likely therefore that Billingsley painted the plants and flowers on the items at Rode directly from his own watercolour sketches. As those depicted are many and varied, comprising exotic and special cultivars, common garden flowers, wild flowers and plants, he must have had access to large gardens and hothouses. It is possible that he accompanied Derby's landscape artist Zachariah Boreman, whom Keys mentions, as he visited nearby country estates, such as Kedleston and Chatsworth in Derbyshire.

It is not surprising that Mrs Bootle, though a much-valued customer of the Derby porcelain factory, was also quite a demanding one.

74. A rare seven-scolloped bowl, thought to have been designed by Mrs Bootle in c.1787–88, from the Derby 'Billingsley' dessert service, painted with red anemone and coreopsis or helenium, '7' mark in red (diameter approx. 8 ½ in, 21.5 cm).

Letters from Joseph Lygo to William Duesbury II hint at her many requests, including the very specific requirements she made for her own design of a scolloped bowl. Examples of this shape survive in the two large and four small rare seven-scolloped shape bowls in the Billingsley-decorated dessert service. Although similar to monteiths or wine glass coolers, the shallowness of the bowls suggests Mrs Bootle may have had another use in mind. The shape was probably based on an existing Derby 'sallet' dish (usually part of a dinner service), and it could be that Mrs Bootle also intended to use her bowls for some sort of salad, if not during the dessert course, then in the intermediate cheese and salad course beforehand.[62] Interestingly, there is at the Bowes Museum in Barnard Castle a pair of Derby porcelain bowls, decorated with exotic birds and gilding, of exactly the same shape as those in the dessert service at Rode.[63] They are most probably two of the '4 Scollop'd Bowls enam'd with different Birds & Gold edge' which Derby supplied to Mrs Bootle at a cost of four guineas on 2 April 1788 (Fig. 75).

The unique Derby 'botanical' dessert service decorated by Billingsley is possibly Mrs Bootle's greatest legacy and it is indeed fortunate that this service remains in the possession and care of Sir Richard Baker Wilbraham, her direct descendant at Rode (Fig. 76). Its reinterpretation of earlier Chelsea 'Hans Sloane' type decoration paradoxically anticipated the later 'botanical' style which continues to be reinterpreted by ceramics manufacturers.

The Samuel Alcock & Co dessert service, which was presented to the family in the 1920s–30s by Sir Francis Joseph of The Hall in nearby Alsager, is a good example of flower-painting of the late Georgian period. The rococo-revival shapes of this unmarked bone china service initially led to a Rockingham attribution; only recently have the well-potted 'writhen' shapes been identified as unique to Alcock's Hill Pottery in Burslem. Made between c.1827–30, the dessert service, which comprises twelve plates, a footed centrepiece and two sets of dishes, is finely

75. A seven-scolloped Derby porcelain bowl, gilded and painted with exotic birds. Now in the Bowes Museum, it was possibly ordered by Mrs Bootle in 1788. Puce-painted 'crossed-baton' mark (diameter approx 8 ½ in, 21.5 cm) (Courtesy of the Bowes Museum).

painted with individual specimen flowers on a white ground within a buff-coloured border; gilding includes stencilled sprigs, banding and dontil edging (Fig. 77). A modern interpretation of earlier botanical wares is Portmeirion's 'Botanic Garden', a popular printed pattern of

76. The Derby 'Billingsley' by candle-light. An elaborate decorative sugar parterre and silver 'Warwick vase' form the centrepiece of the table, with scolloped bowls and ice pails on the Gillow sideboard behind (re-creation courtesy of Peter Brown).

1972 and an appropriate choice as domestic tableware in today's kitchens at Rode.

Mrs Bootle surprised even herself by embracing simple domesticity in old age. In 1799, three years after the death of her husband, she moved in London to 'a very neat comfortable pleasant house', 25 Bedford Square, but spent an increasing amount of time at Lathom. As the lure of London's social and political scenes faded, she became more and more interested in farming, reporting on the vagaries of the weather and the harvesting of crops. She did not live at Lathom Hall, which was from then onwards occupied by her elder son, Edward Bootle Wilbraham, 1st Baron Skelmersdale, and his descendants, but at her 'little gothick cottage', one of the alms houses she had built in its park 'for Poor people'. 'That I should have given up my great house & all my Luxurys', she wrote to her cousin, 'to be permitted by My Son to live in a Hospital: yet so it is; and by my own choice; and were you to see the place, I am sure you would approve of my determination as there are small Luxurys as well as great.' (Fig. 78)

Mrs Bootle inevitably maintained her interest in and influence over the lives of her children, reflecting; 'I have been a good steward to my

77. Flower-painted bone china dessert service by Samuel Alcock & Co, with buff-coloured borders and stencilled, banded and dontil-edged gilding, c.1827–30. Pattern number 1586 painted in puce on each piece (plate diameter 9 in, 23 cm).

78. Portrait of Mrs Bootle painted by Thomas Allen of Liverpool. The Wilbraham Household Account Book records a payment to the artist of twenty-five guineas in 1804.

family; providence having bestowed on me an active mind and a turn for business'. This was not to diminish and, after settling 'Bootle' at Lathom and 'providing amply for my daughters', she prepared for the arrival at Rode of her younger son, 'Wilbraham'. He was to benefit for some years to come from her generosity towards Rode: its house, its park and its fine collection of ceramics.

CHAPTER THREE

Regency Rode

The Grand Tour

'Somewhat taller, a great deal stouter than when I left England, & extremely sunburnt.'

THIS WAS HOW RANDLE WILBRAHAM III (1773–1861) prepared his mother for his return from his Grand Tour in 1798. Mrs Bootle's 'Itinerant Son' had been eager to follow his elder brother to the continent since leaving Christ Church, Oxford, but it was only after serving as a Lieutenant in the Lancashire Militia that he was permitted by his parents to embark on his Grand Tour in 1793. Promised £200 per quarter, he set out for the Netherlands and Germany, commencing a lively correspondence with his mother.[64] In spite of the continuing French Revolutionary Wars, Mrs Bootle was initially reassured by Randle's letters home. However, she soon became concerned by his decision to travel beyond the established routes of the European Grand Tour into more unfamiliar areas of the Middle East. She was especially anxious on hearing from a relative, Peter Tooke, then an agent of the East India Company in Constantinople (now Istanbul), that he wished to see Randle 'out of these burning regions'. But, undeterred, the young adventurer pressed on as far as Persepolis in Persia (now Iran) before returning through the Holy Land, Greece and Italy, completing an unusually extensive tour for the time.

Claiming that 'his travels have only confirmed my prejudices in favour of England', Randle nonetheless enjoyed his experiences of the exotic east: riding on mules 'neither expeditious nor agreeable', learning Persian and making a collection of coins, and having 'his portrait drawn in the dress of the Bedouin Arabs.' (Fig. 80) His far travels *au levant*

79. The ante-room (opposite, see page 87), formerly the entrance hall of the 1752 house, with one of three alcove displays of the Coalport dessert service of c.1805. The chairs are by Gillow and paintings are copies of Raphael's cartoons attributed to Michelangelo Maestri.

80. Watercolour sketch of Randle Wilbraham 'in the dress of the Bedouin Arabs', painted in 1796 while on his Grand Tour.

anticipated the interest in orientalism of Romantic artists and writers, such as Lord Byron who, on his own Grand Tour, took a 'German servant (who has been with Mr. Wilbraham in Persia before).'[65]

In Europe, Randle also found much to admire and amuse. Whilst in Berlin in 1794, he was presented to the King of Prussia, 'booted and spurred... and uncommonly fat'; the Queen, 'extremely partial to the English'; and two princesses, 'very fine girls... and very attentive to strangers'. He later met the Crown Prince, subsequently King Frederick William III, in the royal box at the opera. Twice Randle visited Dresden's 'Picture Gallery, which is beyond expression charming, as well as the Porcelain.' Sharing his mother's interest in horticulture, he described his visit the same year to the palace of Schönbrunn, near Vienna, where he saw 'a truly imperial collection of plants reckoned the finest in Europe. Mary Theresa began it and Joseph spared no expence to bring it to perfection, he sent the gardener, a clever intelligent man, to America, the East & West Indies, in quest of plants of which he has brought many which were unknown before in Europe. They are all in great perfection & would be an inexhaustible store of amusement to any botanist.'

Three years later Randle again had an opportunity to visit gardens, at the impressive palace at Caserta in Italy. Accompanying him were the British Ambassador to Naples, Sir William Hamilton, and his wife, Emma, Lady Hamilton, with whom Randle 'talked Lancashire'. 'The longer I stay out of England, the more John Bullish I become,' he wrote to his mother. The threat of the French invasion did not unduly worry Randle who complained that Naples 'is perfectly tiresome at present as there is no society...' Those who did leave the city in haste might have regretted it later; a number of the paintings now at Rode are believed to have been part of the collection left there by the Earl of Bristol. When Randle did encounter French troops on the road from Rome, they acted 'with great moderation', although he later declared, 'in all the north of Italy [the French] have behaved most shamefully.' Proceeding swiftly to Siena, Florence, Verona and Venice, 'perhaps the most singular place I have seen', Randle finally sailed back to the comparative safety of London in April 1798. He had been away for a total of four years, four months and four days.[66]

Return to Rode

'You have had a most interesting journey, Mr Wilbraham, now take my advice and don't talk about it.' Whether or not Randle did accept the counsel he recounted from 'a woman of the world' is not known. However, his adventures over, he was eager to settle down and by the end of the year had married Letitia, daughter of the Rev. Edward Rudd, rector of Houghton-le-Spring in County Durham, and niece of Richard Pepper Arden, Master of the Rolls.[67] 'The connexion is very unobjec-

tionable', wrote Mrs Bootle to her cousin, adding that Randle had admired his wife 'when quite a young boy and she a girl; the flame has been smothering in his bosom all this time and her being brought in his Way by her mother who I believe always wisht it; it has had the desird effect: and has rekindled the dormant embers... Wilbraham has a turn for Country life, so their plan at present is to take a house [Mount Hall] in Yorkshire that being her County, while I get his fathers House in Cheshire ready for him to inhabit.'

Mrs Bootle attended to this business with typical enthusiasm. By November 1799 she was writing: 'His father's house I am filling up and putting in order for him; it has not been inhabited many years he and his wife purpose inhabiting it at Christmas; she will before then I hope have added to their family'. In fact, Randle, Letitia and their baby daughter were not to take possession of Rode until February 1800, 'poor fellow he has much to encounter as he comes to a House full of Workmen; a road to turn; Lands not laid out and a garden to make; but he is young and will I have no doubt make his own affairs his employment and the more his mind is occupied the better.'

Randle was to be occupied for over ten years as he transformed Rode into a fashionable Regency home. Although the Regency period – when the Prince of Wales acted as Regent for his father, 'mad' King George III – lasted only from 1811 until 1820, the decorative style known as Regency Classicism spanned the years 1800 until 1830 – the year the Regent, by then King George IV, died. Characteristic of the style was the combination of the simple lines of both Greek and Roman classical design with a *mélange* of other motifs, from Ancient Egypt, nature, the rococo, and, surprisingly, the French Empire style.

Fortunately, Randle Wilbraham's Account Books for the period 1799–1813 have survived, recording the names of many involved in Rode's Regency redesign. Amongst them was John Hope (1734–1808), the architect employed to remodel the house, whose payment of £500 was recorded in November 1799. Hope, a Liverpool architect, had previously designed Piece Hall at Halifax in Yorkshire and Wavertree's Holy Trinity Church, said to be the best Georgian Church in Liverpool. He also worked on Ince Blundell Hall, the Liverpool seat of Henry Blundell, then famed for his Grand Tour collections.

Hope's alterations at Rode were considerable, the main one being the reorientation of the house's entrance from the north, garden side to its current west side. The existing three-sided bays were then rebuilt in semi-circular form and, to give the house a symmetrical appearance, an identical bay was added to the right of the new entrance. The dark cherry red bricks, which today mark out these later additions, were then concealed by stucco which covered the façade of the house. Large windows were added to each of the bays' three floors, the pairs of outer windows being bricked in during the mid-nineteenth century. The

creation of the new bay, over the arcaded courtyard between the main house and its service wing, enabled additional service accommodation, including two new back stairs, to be built within its interior. At the same time, the old ground-floor parlour was converted into today's generous entrance hall. It is probable that alterations were also made in the early 1800s to the exterior of both the service wing and the adjacent stable block, both of which feature circular and round-headed windows and a hipped roof and cupola, similar to Hope's design at Piece Hall.[68] A letter written by Mrs Bootle in 1801 suggests that Randle might also have been planning to build a chapel: 'My Son Wilbraham his Wife and one little girl & something that is expected next month; are in the country where he is extremely busy in building a Chapel to his house, and making everything comfortable about him, is an active Magistrate, and a very Useful Member of Society in his Neighbourhood.' As no evidence has been found of a chapel either inside or adjoining the house it seems likely that Randle became preoccupied with other issues, before involving himself in the foundation of a chapel in the adjacent village of Scholar Green. This was known by several different names: 'Dobbs's Chapel', after Henry Dobbs of nearby Ramsdell Hall who had built it in 1808; 'St. Thomas's Chapel'; 'Rode Chapel', and eventually 'The Chapel of the Holy Trinity'. Whilst still occasionally visiting Astbury Church, the Wilbraham family was to adopt the chapel as its principal place of worship until the buiding of All Saints' Church in Old Rode in 1864.[69]

Repton at Rode

Further developments to Rode's surrounding parkland and gardens drew on ideas prepared for Randle's parents by Humphry Repton (1752–1818). The self-appointed successor to 'Capability' Brown, Repton was essentially an artist rather than a gardener. His 'before and after' fold-out watercolour sketches, bound in either red morocco leather or calf, presented polite society with a means of envisaging his designs of a more picturesque and lush landscape park, with restored terraces and smaller, more intimate flower gardens. Repton's accounts for July and August of 1790 record a total charge of £55 13s 0d for two visits 'to, at and from Rode Hall' in preparation of its Red Book.[70] His accompanying note to Richard Wilbraham Bootle read: 'Notwithstanding you hinted to me that a written digest of the intended improvements at Rode Hall would not be requisite yet, I hope you will not be displeased that I have transcribed in the following pages the substance of the letters which I have had the honour to write on the subject.' Such obsequiousness was countered with his opinion that 'The landscape in its present state is not unpleasing considered merely as a landscape, but it is more consistent with the view from a cottage or farmhouse than from the portico of a gentleman's seat.' (Fig. 81)

81. A page from Rode's Red Book, prepared by Humphry Repton for Mrs Bootle in 1790.

Suitably chastened, Randle set about implementing some of Repton's proposals by employing in 1803 a Cheshire gardener, John Webb (1754–1828). Webb had already established a reputation as a pupil of William Eames at Crewe Hall and was subsequently to work at Tatton, perhaps on the recommendation of the Wilbraham family. Over the next decade, Webb and his team of gardeners were to create a new entrance drive way, lay out the five-acre Wild Garden in the undulating hollow to the west of the house, and create two artificial lakes: the 'lesser water' or 'Stew Pond' and the one-mile long 'large water' known as 'Rode Pool'.

Much planting was also carried out and a new greenhouse built in 1802. Account Books record payments for unspecified seeds, plants, forest trees and shrubs, as well as that noted on 30 September 1803: 'Present to Mrs W for her flower garden £3 3s 0d.' Letitia was evidently interested in plants and flowers as amongst the extensive collection of books which she brought to Rode were numerous volumes of Curtis's *Botanical Magazine* bearing her bookplates. Early nineteenth-century publications such as *The Floricultural Cabinet* and *Florists' Magazine* and *The Gentleman Farmer* in the library at Rode are testimony to the Wilbrahams' continuing interest in horticulture and agriculture.

Furnishing the Regency home

As the house and garden were improved, Randle Wilbraham and Letitia began to furnish their new home. Payments were recorded for 'Scotch' and 'Turkey' carpets, as well as chimneypieces by 'Cooke' and 'Rowe'. The latter was probably Peter Rouw the Younger, who was appointed 'sculptor-modeller' to HRH, the Prince of Wales, in 1807. Whilst

82. An invoice and receipt to Mrs Wilbraham Bootle for china purchased from Mortlocks, London retailers specialising in Coalport wares, dated 5 March 1802.

furniture was purchased from 'Gregson & Buller, upholsterers' and from 'Satterfields' of Manchester, the name which occurs most frequently is that of the successful London-based Regency designer, George Oakley, whose French Empire style of furniture was also to win royal patronage.

Randle's accounts record other payments for both plate and silver from 'Gilbert', possibly the London silversmiths Andrew Fogelberg and Stephen Gilbert. Ensuring that the rituals of the tea ceremony were maintained at Rode, Mrs Bootle also purchased for her son 'a Tea urn £57-0-0 and a coffee pot £12-0-0' from George Gray of London and 'tea spoons, 2 pairs tongs £7-15-0 with cases, and engraving crests £2-1-6 extra' from Robert Makepeace.

Occasional purchases of ceramics were also recorded. Whilst the Rudd family had been Wedgwood enthusiasts[71] and the Wilbraham Bootles had later favoured Derby and Worcester, it was a lesser-known manufacturer whose name first appears in the Wilbrahams' Account Books; 'Wilson Handley [sic] for Pottery Ware £4 1s 0d', recorded on 17 March 1802, probably refers to the brothers Robert and David Wilson of Church Works in Hanley, who produced lustre ware and cream ware from c.1795–1818. Their wares were certainly known to Admiral Lord Nelson whose Wilson cream-ware dinner service is represented in the collection of the National Maritime Museum.

Examples of the Wilson pottery purchased by the Wilbrahams no longer survive. Nor, unfortunately, does the china presented to Randle and Letitia by Mrs Bootle that same year. This was described as 'Mortlock Tea China' and cost £10 10s 0d, the same price then paid for '4 doz Damask Napkins'. An invoice (Fig. 82) found amongst family papers indicates that the china was 'A Compleat Tea & Coffee Sett, Rich Mosaic Pattern, Highly Gilt' bought from 'Mess. John & Wm Mortlock, Manufacturers of Colebrook Dale Porcelain, To Her Majesty and All the Royal Family'.[72] Dated 5 March 1802, the invoice is one of the earliest recorded with this misleading description, for Mortlocks were not 'manufacturers' but independent china retailers in London; 'Colebrook Dale Porcelain' was supplied to them by manufacturers in Coalport, near Coalbrookdale in Shropshire.[73] At that time, there were two rival companies operating there: Rose & Co, a thriving hybrid hard-paste porcelain factory founded by John Rose in c.1791, and Reynolds, Horton & Rose, its adjacent factory which Thomas Rose, John's brother, had run in direct competition since 1800.

It is not clear whether Mrs Bootle's purchases were manufactured at Coalport or taken from the stock supplied to Mortlock by other suppliers. As well as the 'Mosaic Pattern', a generic name given to the chequered border design derived from Meissen, other items included in the package for 'R Wilbraham Rhode Hall Cheshire' were two unspecified tureen covers and stands and 'Potting Potts', probably blue and white useful wares of the type produced at Coalport. 'Mrs Rudd Nicholas

Lane Chester', presumably Letitia's mother, also benefited from Mrs Bootle's generosity; her 'Compleat Tea & Coffee Sett New Red Leaf and Gold Border £7 7s 0d' was probably painted in iron red enamels and gilt, a decoration used quite frequently at Coalport.

Mrs Bootle also took the opportunity of acquiring for herself two bread & butter plates 'Made & Painted' to match a 'Dresden' pattern. The 'Pair of Paper Cases' she purchased for sixteen shillings, only two shillings less than her plates, were possibly plain wooden tea caddies for home decoration using strips of rolled paper.[74] This was a popular and genteel pastime for Georgian ladies, as were 'scissor-cuts' or the making of silhouette portraits. Letitia Wilbraham's own album of 'scissor-cut' cupids, similar to some Coalport patterns of the early 1800s, still remains at Rode.

Interestingly, an entry in Randle's accounts in April 1802 records a further payment of £35 17s 0d to 'Mortlock for China' (Fig. 83) but no invoice has been found to identify the porcelain. The date is probably too early to relate to the Coalport dessert service, now displayed in the ante-room at Rode (Fig. 79). This is believed to be from Thomas Rose's

83. 'Mortlock for China', an entry, dated 27 April 1802, in Randle Wilbraham's Account Book.

84. A covered cream or sugar tureen and stand, one of a pair from the Coalport dessert service, made by Anstice, Horton & Rose and beautifully painted and gilded in the fashionable 'Japan' style, c.1805 (height 5 ¼ in, 13 cm).

85. One of a pair of ice pails, with flat coiled handles, from the 'Japan' patterned Coalport dessert service, made by Anstice, Horton & Rose in c.1805 (height 10 in, 25 cm).

Anstice, Horton & Rose factory which operated from 1803 until 1814 (when it merged with Rose & Co). The beautiful, highly decorative Japan-type pattern is painted with three large orange and white flowers with green leaves against a cobalt blue and gold patterned ground. It comprises the standard Coalport dessert items of c.1805–10: lobed-edged plates; shell-, oval- and square-shaped dishes; a pair of lidded oval sugar and cream tureens and stands, with distinctive rounded scroll knobs and handles; a rectangular dish on four scrolled feet, and a pair of impressive ice pails with flat coiled handles (Figs. 84–85). A similar-sized 'dessert service of the Colebrook-Dale in imitation of the old colored Japan' was sold by Mr Christie in London in 1808 for £6 16s 0d.[75] Coalport produced a great variety of such fashionable 'Japan' patterns, a number of which were painted by Thomas Pardoe, an independent Bristol-based decorator sometimes employed by Mortlocks.

The Rode Collection includes further decorative services by Coalport. The earliest is a gilded blue-scale dessert service with flower sprays in shaped reserves, possibly ordered by the Wilbrahams to match the family's earlier Worcester 'Dr Wall' service. As with the Japan-type service, it is likely to be from the Anstice, Horton & Rose factory and

shares some of its shapes, including lobed-edged dessert plates, shell dishes and a rectangular bowl on four scrolled feet. Its two lidded tureens and stands are of a different form, circular with a Meissen-inspired pinecone knop. A similar pattern, of c.1805, is represented in the collection of the Victoria & Albert Museum in London.

Other Coalport services at Rode date from the 1820s by which time the factory's body had changed to bone china. Further experimentation in the early 1800s had seen manufacturers introduce numerous new ceramic bodies. Stone china, a fine yet durable stoneware, was first patented in north Staffordshire by Turner of Lane End before its subsequent development by Spode and Miles Mason, whilst felspar porcelain, which contained felspar (petuntse) found on the Shropshire/Wales border, was originated by Coalport. A 'New Embossed' tea service at Rode, with relief-moulded cobalt-blue panels alternating with flat reserves of hand-painted floral sprays,[76] is a good example of Coalport's then similar style to the Welsh factories of Swansea and Nantgarw from whom John Rose reportedly purchased materials. In quite a different style is a green-bordered tea service, bearing Coalport's impressed numeral '2', which displays ornate rococo-revival shapes of the sort usually associated with the Yorkshire manufacturer, Rockingham, during the 1820s–30s.

By then, Rode had a new lady of the house, Randle's first wife, Letitia, having died in March 1805. Mrs Bootle had expressed her concerns for her daughter-in-law some two years earlier when she wrote in one of the last surviving letters to her cousin:

> I have been near a fortnight in the family of my youngest Son Wilbraham and a Happy One they are; she proves a most fruitful Vine indeed; has three fine Olive branches already the eldest of whom is but three years old; and in the course of two or three weeks another is expected; vegetation here comes on rather faster than can be wish'd for the health of the bearer but whatever is is right is the best Opinion to adopt.

Household accounts present the financial rather than the human loss, recording payment to the 'Dispensary at Etruria', the hospital in the nearby Potteries; to the funeral undertaker, and finally to Rouw for his memorial tablet to Letitia in Astbury Church. Her portrait by Sir William Beechey, portrait painter to Queen Charlotte, hangs in the drawing room at Rode.

Appreciating Letitia's interest in flowers and plants, it is possible that Mrs Bootle presented the Chelsea 'Hans Sloane' plates and Derby 'botanical' service to her on her arrival at Rode in 1800. Certainly, it seems that the Derby service was in the Wilbrahams' possession in 1806 when Randle visited the Spode factory and ordered its replacement ice pails. His visit, as one of the party accompanying the Prince Regent and his brother, the Duke of Clarence, later William IV, was a very grand

86. One of a pair of Spode bone china ice pails, replacements made for the Derby 'Billingsley' dessert service, c.1807. Spode 'Prince of Wales feathers' mark on base and cover (height 9 ½ in, 24 cm).

occasion, not only for Randle, but for the expanding north-Staffordshire ceramics industry. A report in the Staffordshire Sentinel on 20 September of that year read:

> On Friday morning their Royal Highnesses, accompanied by the Marquis of Stafford, Lord Harrowby, Lord Crewe, Lord Gower, Lord Petersham, Lord Granville Leveson Gower, the Lord Chief Baron, Mr Vernon, Mr MacDonald, The Rev. Archdeacon Woodhouse, Col. Leigh, Mr Wilbraham, Major Bloomfield, Mr Heathcote, etc. etc. proceeded to Stoke-upon-Trent, when they were received under arms by the Stoke, Penkhull and Fenton Volunteers, commanded by Lieut. Col,. Whalley, and immediately visited the extensive manufactory of Mr Spode.

As a result of the royal visit, Josiah Spode II was appointed 'Potter to His Royal Highness the Prince of Wales' and devised a special 'Prince of Wales' feathers' mark for his china to commemorate the royal visit. Used only rarely between c.1806–10, this printed mark appears not only on one of the matching 'botanical' ice pails at Rode (Fig. 86) but also on a number of plates decorated with 'Angoulême Sprigs', a pattern of cornflowers, sometimes called 'Barbeaux', originating at Sèvres.[77] These items were most probably ordered by Randle during his visit or soon after and their payment is recorded in his Account Book on 8 May

1807: 'Spode for China made at Stoke £18 10s 6d.' Additional dessert ware items in the collection were probably matched by other manufacturers of this fashionable pattern.

Other popular items produced by Spode at the time of Randle's visit were 'bat-printed' tea wares, such as those still in use at Rode (Fig. 88). The bat- or black-printing process involved a sheet of animal glue, called a 'bat' being pressed onto an engraved and oiled copper plate to pick up its design. When pressed onto glazed ceramic ware, the bat transferred the oiled design which was then dusted with powdered metallic oxide colour and fixed to the glaze by a further firing. Rode's bone china tea wares are decorated with landscape views typical of the Regency period. Taken from contemporary prints and drawings, they include views of rural scenes and country cottages, ruined castles and abbeys, and the genteel enjoying their country estates.

At the time of the royal visit, Spode was especially known for its underglaze blue patterns printed from hand-engraved copper plates. The development of England's porcelain industry had led to the eventual cessation in 1799 of the Hon. East India Company's importation of Chinese blue-and-white porcelain. Previously monopolising the market with the availability of inexpensive imitations or 'matchings' were the soft-paste porcelain manufacturers Worcester and Thomas Turner's Caughley factory in Shropshire (acquired by John Rose of Coalport in 1799). However, Spode's success in perfecting the process of underglaze blue printing on biscuit earthenware in c.1784 allowed it to subsequently dominate the field. Rode's Account Books record the purchase in 1802 of '2 blue and white tureens Spode £0 19s 0d', whilst its china cellars have a lidded fan-shaped dish remaining from a supper set decorated in Spode's Chinese-style 'Net' pattern. Examples of other early nineteenth century blue-and-white patterns at Rode include Rogers' 'Zebra' and 'Camel', and Wedgwood's 'Blue Basket'.

Following its visit to Spode, the Prince of Wales' party went to view the canal side factories of Wedgwood at Etruria, then managed by Josiah Wedgwood II and Thomas Byerley, and of Davenport at Longport, a large family-run glass, pottery and porcelain manufactory, where 'Their Royal Highnesses condescendingly partook of cake and wine.' Although the Davenport glass Randle purchased for £7 4s 0d in December of 1809 no longer survives, Rode has two pairs of earthenware candlesticks made by the factory in c.1815 (Fig. 87).

87. A pair of early nineteenth-century Davenport candlesticks, earthenware with regency-style green enamelled and gilt decoration. Impressed factory mark (height 11 ½ in, 29 cm).

The elegant Regency style and bold green colour of the Davenport candlesticks would certainly have suited the decorative schemes implemented by Randle's second wife, Sibylla, whom he had married in 1808. As the daughter of Philip Egerton Esq. (c.1732–86) of Oulton in Cheshire, Sibylla was related to Randle's nephew, Wilbraham Egerton of Tatton. His employment of the Cheshire architect, Lewis Wyatt, to complete Tatton's refurbishment may have prompted Randle and Sibylla to

88. Examples of early nineteenth-century Spode bat printed tearwares at Rode: left to right, a tea bowl printed with pattern P276, an unnamed house; a saucer printed with pattern P269, Sherborne Castle in Oxfordshire, and a coffee can and saucer printed with pattern P243, a View of Llangollen (saucer diameter 5 ¼ in, 13 cm).

commission Wyatt to undertake similar improvements at Rode. Paid £26 5s 0d 'for plans' in 1810, Wyatt redesigned the interior of the ground floor, replacing the original library with today's dining room and creating the current library from the old dining room at the front of the house.

The new dining room was extended to the south with an apse, decorated with rays of foliage, and given a shallow, vaulted ceiling, the ribs of which were supported by two pairs of green scagliola Ionic columns. The black marble fireplace decorated with bronze masks is attributed to Benjamin Lewis Vulliamy who supplied similar designs to Tatton at this time.[78] Today's redecoration has restored the dining room to its original Regency or 'English Empire' style, the cool green walls contrasting with more decorative Neo-classical elements, such as the egg-and-dart cornice mouldings and gilded capitols. A French window opening onto the garden and its external entrance were also the work of Wyatt. The house's old north-side portico entrance may have been altered at this time, gaining four Doric columns with carvings to the inner and outer sides of its entablature.

Whilst the dining room was formal and elegant, the new library was more comfortable and welcoming, becoming the family's principal living room from this time onwards. It still retained the essential furnishings of a library, acquiring a pair of celestial and terrestrial globes published by J & W Carey of The Strand in 1799 and 1815, and new bowed lightwood bookcases fitted by Gillow, the Lancaster furniture retailers. 'Sam Harris, Gillow's man' had been paid £5 0s 0d to visit Rode in September 1812, securing an order recorded by the Wilbrahams in January of the following year: 'Messrs Gillow Upholsterers £762 3s 3d.' Included in this payment were the mahogany dining table and bespoke segmental sideboard which today remain in the dining room. The family's expenditure continued until 1818 according to Gillow's accounts, which itemised three crates of satinwood chairs, a billiard table and two easy chairs. With Tatton, Rode is especially renowned for the quality of its Gillow furniture but also of particular note is a Pembroke table in the drawing room; although the Neo-classical marquetry of this drop-leaf

side table is sometimes associated with Pierre Langlois, Rode's table is now attributed to John Cobb (c.1715–78), cabinet maker to George III. (An interesting contemporary reinterpretation of the style is seen in the design of a table top at Rode commissioned from David Linley in 1994.)

Sibylla Wilbraham, like her predecessors at Rode, was also interested in gardening. Encouraged by her sister, Lady Elizabeth Broughton of Doddington Hall, she spent lavishly on its garden, paying in 1812 the sculptor Francis Bernasconi of Buckingham £49 14s 9d for a fountain, which unfortunately no longer exists. The first terraced rockeries in the Wild Garden date from around this time as does the rustic fossil- and mineral-lined grotto, such picturesque caves then still enjoying a prolonged revival amongst Georgian naturalists and romantic gentlewomen. A stone cross and an unusual elaborately carved table and chair recall 'Wilbraham's folly', the Gothick ruined castle built at Mow Cop by Randle II.

The 'hill of Mole Cop or Mow Cop' was mentioned in notes accompanying J P Neale's 1824 engraving of Rode (Fig. 89). This description also drew attention to the grounds 'laid out in the modern style' and the view to the north which encompassed 'a great part of Cheshire with the Hills of Delamere Forest and the rock on which are the ruins of Beeston Castle.' By the early 1820s it appears that Randle III and Sibylla had built a 'large and handsome' conservatory over the front of the house. A granddaughter, Katharine Frances Baker Wilbraham, who was to inherit Rode, mentioned the conservatory in her memoir, noting that she could 'still smell the tall plants of Humea Fragram standing on china

89. Rode Hall viewed from the garden, an engraving from J.P.Neale's 'Views of the Seats of Noblemen and Gentlemen in England, Wales, Scotland and Ireland', 1824.

90. A pair of porcelain bulb pots with covers, made in a distinctive shape associated with the W*** factory. Their landscape scenes are delicately painted in monochrome and identified on their bases as 'Dunster Castle, the Seat of Mr Luttrell', left, and 'A View of Mr Hoare's Pantheon at Stourhead', right, c.1800 (height 6 in, 15 cm).

barrels on either side.' Today the conservatory no longer exists but the same barrel-shaped seats, Canton-enamelled in *famille rose* colours, decorate the staircase at Rode, though without their strongly scented incense plants.

It might have been for their conservatory that the Wilbrahams made several purchases of 'Garden Pots' from 'Messrs Wedgwood & Co'. A letter written in 1810 by Samuel Priest, presumably the Wilbrahams' steward, suggests that the quantities were large; in that instance some 500 different-sized pots were required, with the request that they should not 'be so hard Burnt as the last was'.[79] In the same order, Priest asked for 'four and a half dozen white Dutch Tiles... for a very Particular Piece of Work', possibly a fireplace or stove in the conservatory.

John Wedgwood, a son of Josiah I and an occasional partner at the works between 1800–1812, was fascinated by botany, horticulture and the cultivation of exotic plants and fruit. He founded the Society of the Improvement of Horticulture, later to become known as the Royal Horticultural Society, and acted as chairman at its inaugural meeting in 1804. During the years in which he was associated with the Etruria pottery, he initiated the introduction of a number of botanical designs.

It is possible that he sanctioned, as a favour to the Wilbraham family, the company's buying in of quantities of utilitarian terracotta garden pots for the planting of seedlings, whilst overseeing the continued manufacture of a variety of decorative garden pots and stands.

Amongst the many decorative indoor flower- and garden pots produced by ceramics manufacturers were a number of popular bough-pots and bulb-pots whose covers had small holes for flowers, such as crocuses, and sometimes large collared cups for hyacinths. The collection at Rode has two pairs of such pots. One pair of unmarked porcelain bulb-pots, thought to date from c.1800, feature landscape views painted in

the monochrome style sometimes used by John Cutts at Pinxton and William Billingsley at Mansfield, both Derby-trained artists. The distinctive shape of the bulb-pots, flat-backed and semi-circular with three gilded bun feet, is often associated with the obscure W(***) wares (Fig. 90). They provide an interesting contrast with a pair of Wedgwood bough-pots-cum-pastille burners, dating from c.1815, whose relief anthemion and rosette decoration reflect the Etruria pottery's continuing classical influence (Fig. 91).

That the family also continued to purchase Derby porcelain is evident from an entry in the Household Accounts Book in December 1809: 'Set of Table China Derby Cost £81 0s 0d'. A separate invoice[80] identified this as the extensive bone-china dinner service, 'Old Japan', which

91. One of a pair of combined pastille-burners and bough pots, relief decorated in brown with a vine border and an anthemion and rosette to the square base, c.1815. Impressed Wedgwood mark (height 8 in, 20 cm).

92. Duesbury & Kean's invoice of 16 December 1809 to Mrs Bootle for the Derby 'Old Japan' service at Rode.

93. Oval sauce tureen, cover and stand from the Derby 'Old Japan' pattern, 1809. Duesbury & Kean mark in red (length of stand 9 ¼ in, 23.5 cm).

still remains at Rode (Fig. 92). It had been 'b't of Duesbury & Kean' not by Randle but by his mother, Mrs Bootle, as a gift to him and his new wife, Sibylla (whose father's purchases of Derby porcelain can be traced back to the early 1770s.)[81] First introduced between c.1795 and 1800, the design is today associated with pattern number 383, a part-printed version introduced by a later company, Royal Crown Derby, in 1878.[82] Like Rode's 'Billingsley' dessert service, its design reflects the eighteenth- and early nineteenth-century preoccupation with botanical studies, but its central motif of a Japanese flowering shrub demonstrates the more stylised interpretation common to the Imari export porcelain it imitates.

Randle and Sibylla evidently maintained the well-used service which today comprises over 120 items. Whilst most are later 'matchings', produced either by Derby during the 1830s or by other unknown

94. Square corner dish and cover, described by Mrs Bootle as a 'pincushion dish', from the Derby 'Old Japan' pattern, 1809. Duesbury & Kean mark in red (diameter 9 ¾ in, 24.8 cm).

manufacturers in the Potteries, a number of pieces remain from the original order. They include dinner plates; soup dishes; different sized oval dishes; an oval soup tureen and cover; a complete sauce tureen, cover and stand; (Fig. 93) two oval or melon shaped 'sallad bowls', and 'corner dishes & covers' (square-shaped covered vegetable tureens similar to Georgian silver entrée dishes) (Fig. 94). With typical efficiency, Mrs Bootle re-listed all the items she purchased, describing the dinner plates as 'Flat Plates' and the 'corner dishes & covers' as 'Pincushion Dishes', a term also used in earlier Derby factory records.

Accompanying the Rode 1809 invoice and written in the same hand is a receipt reading: 'London, Dec 30th 1809, Received of Mrs Bootle, Eighty one pounds six shillings & six pence for China as per Acct for Messrs Duesbury & Kean £81 6s 6d'. This is signed 'Thos Tatem', Lygo's successor and later manager of Derby's new showroom in Old Bond Street, a short drive by carriage from Mrs Bootle's Bedford Square home. (Fig. 95) The next few years were to see a change in direction for the Derby works including increased production of less expensive Imari-style Japan patterns. The choice of 'Old Japan', as with the Derby 'botanical' service, shows that Mrs Bootle was again at the forefront of fashionable taste. The date of the invoice, 16 December, suggests that the dinner service may have been intended as a Christmas present. Whether or not Mrs Bootle joined Randle and his family for the festive season is not known but the 'Old Japan' would have looked most impressive in the Regency dining room at Rode where items from the original 1809 service are today displayed.[83]

The Derby 'Old Japan' order is the last recorded purchase of china by Mrs Bootle who died five years later in 1813. *The Gentleman's Magazine* reported her death on 10 April:

> In Bedford Square, in her 80th year, Mrs Wilbraham Bootle, relict of the late Richard Wilbraham Bootle Esq. of Lathom House, and Rhode Hall, Cheshire.

Her will stipulated that she was to be buried not at Lathom but by the side of her husband at Astbury Church, 'in the most private manner possible'. She further directed that thirty pounds 'be distributed amongst the poor of the neighbourhood of Rode, in the parish of Astbury, Lawton and Alsager, instead of tea.' Her will makes no mention of the porcelain she had enjoyed collecting so much but doubtless the ever-competent matriarch had already overseen its fair and efficient dispersal amongst her large family.

Mrs Bootle's public life had demonstrated all the responsibilities of the Georgian élite, of 'politeness', prudence and propriety, but in private she indulged in many of its genteel passions, that for china continued at Rode as the Wilbraham family entered a new Victorian era.

95. Prompt payment by Mrs Bootle: Duesbury & Kean's receipt of 30 December 1809 for the Derby 'Old Japan' service at Rode.

CHAPTER FOUR

Victorian Arts and Crafts at Rode

The mid-Victorian era saw much of the Midlands and north of England transformed into the industrial 'workshop of the world', churning out coal and cotton, iron and steel, bricks and tiles, pottery and a plethora of ornamental objects. Not far from these busy areas of mass manufacture, Rode remained, undisturbed, in the tranquil Cheshire countryside.

The estate's peaceful continuance was especially apparent when Randle Wilbraham III and Sibylla were succeeded in 1861 by Randle Wilbraham IV and Sibella. In many ways, the life of 'Young Randle' (1801–87) shadowed that of 'Old Randle', his father: a Grand Tour to Italy in 1824–25 (where his family was already enjoying an extended visit), followed by marriage in 1833, and thereafter estate management and involvement in church affairs and charities in Cheshire. The lifestyle of Sibella (Sybilla's niece) also followed the pattern set by previous Wilbraham wives who were expected to organise the busy household and maintain the large garden, skills she would have acquired as a daughter of William Egerton of Gresford Lodge in North Wales.

The Gothic revival

Moving from Rode House in nearby Rode Heath, Randle and Sibella (Fig. 96) were eager to initiate changes at Rode. However, the early years of their tenure were devoted not to the house and estate but to the building of All Saints', a new church at the end of the driveway. Although accommodating a family chapel for the Wilbrahams, the church's main purpose was to serve the parishioners of Odd Rode. The return to High Anglican churchmanship which characterised the religious revival in Britain had seen the building and refurbishment of numerous churches, many by Sir George Gilbert Scott (1811–78). Amongst his restorations were Astbury Church in Cheshire and,

(opposite) Detail from 'Bluebeard and Gloriana' (see complete work on page 104).

96. A small sepia photograph of Sibella Wilbraham taken in c.1862.

between 1854–56, St James's in Audley, Staffordshire, where Randle's half-brother, the Rev. Charles Philip Wilbraham was then vicar. Charles, a talented amateur painter, was a frequent visitor to Rode, just five miles from Audley vicarage, and it was doubtless he who suggested Scott as a suitable architect for All Saints' (Fig. 97).

The Gothic Revival style which Scott favoured, based on medieval forms and decoration, had been pioneered by A W N Pugin whose best-known building, London's Houses of Parliament, made much use of medieval-style encaustic (inlaid) tiles supplied by Minton. When Scott's designs were implemented at All Saints', the aisles and chancel were also laid with Minton tiles but whereas in 1845 Herbert Minton had freely donated his firm's tiles to Old Randle for a church in nearby Smallwood,[84] by 1864, the year All Saints' was completed, such charitable gifts had ceased and a payment of £674 4s 0d was duly demanded from Young Randle.

Founded in Stoke-on-Trent in 1793, Minton was one of Victorian Britain's most successful ceramics manufacturers, its eclectic reinterpretations of past styles having won many plaudits at the 1851 Great Exhibition in Hyde Park. The Wilbraham family acquired a variety of Minton decorative and useful table wares throughout the nineteenth century; amongst those still remaining at Rode is a Sèvres-style monogrammed writing set commemorating Randle and Sibella's marriage in 1833; a rococo-revival embossed tea set with a gilded ruby ground; a pair of turquoise-grounded 'Pilgrim Bottles', hand-painted with flowers (Fig. 98); and examples of the 'Wilbraham tray' (of which more later) produced in majolica, a lead-glazed earthenware imitating Italian maiolica. Although Minton coined the name Parian for its biscuit porcelain made in imitation of marble, the invention in the 1840s was that of Copeland ('late Spode') whose figurative sculpture, 'Solitude', by John Lawlor (1820–1901) today stands in the entrance hall at Rode. In common with all British decorative objects made since 1842, its design would have been registered or patented to protect against copying by rival manufacturers.

John Lawlor was one of numerous sculptors who contributed designs to Scott's Albert Memorial, the national monument erected to Prince Albert, Queen Victoria's husband and consort, who had been the main instigator of the 1851 Great Exhibition. Another contributor to the memorial was the London sculptor J B Philip RA (1824–75) whose statue of Christ in All Saints' was donated by Sibella Wilbraham. According to a memoir of c.1919 written by her niece, Katharine Frances Baker Wilbraham, 'Aunt "Bella" had shown the 'greatest interest and delight' in furnishing the church. As well as presenting Philip's sculpture, she also negotiated the donation of a stained-glass window, a memorial to Old Randle from his niece, Miss C E Arden (a descendent of Richard Pepper Arden, Master of the Rolls). The designers and

97. A full-length portrait of Randle Wilbraham IV standing in the chantry of All Saints' Church, Odd Rode, painted by Alphonse Legros.

98. A pair of Minton majolica 'Pilgrim Bottles', painted with honeysuckle, left, and lilies, right, c.1870. Impressed 'Minton' and shape number '1348' (height 8 in, 20 cm).

makers of the window, Arthur and Michael O'Connor, did not meet with the unqualified approval of Scott who, in a letter to Sibella, described their work as 'Michelangelo and water with very little of the stronger stuff.' Sourcing other furnishings for the church was equally challenging; in response to her enquiry regarding the church's kneelers, Sibella received the terse comment: 'The green and black matting as in the House of Lords is quite unsuitable for hassocks as it consists chiefly of horsehair.'[85]

Wisely, perhaps, Sibella chose not to implement the Gothic Revival style in her redecoration of Rode Hall. 'This was done very thoroughly,' Katharine was to write, 'as my Aunt loved beautiful things & would have enjoyed entertaining largely. Unfortunately,' she continued, 'Uncle Randle always kept to himself the amount of his income.' This was undoubtedly a reference to the fall in family fortunes owing to heavy debts incurred in Randle's father's time, to the costs he bore for the building of All Saints' Church, and to the loss of income from the estate caused by Cheshire's devastating cattle plague in 1866. Although forced to sell off estates in Huxley and Stapleford in Cheshire, Randle nonetheless claimed no rent from his tenant farmers for twelve months to allow them to recover their stock.

Whilst funds were made available for some improvements to the exterior of Rode Hall, for example, the addition of French-style balconies to first-floor windows at the entrance of the house, there could be no extravagant expenditure during the late nineteenth century, and the bricking in of the side windows in the house's Regency bays was probably a cost-cutting measure to prevent heat loss from the large rooms. (In the 1980s it was discovered that an upper-floor bay at the back of the house had been completely bricked in, complete with curtain hangings and a bed!) Late Victorian photographs show that the house was still

stuccoed and that the old conservatory had been converted to a fashionable *porte-cochère* (carriage entrance) which the family called 'St Pancras'. On the ground floor, the library remained the family's sitting room but the drawing room was barely used, most of its furniture having been taken to King's Building in Chester where Sibylla Wilbraham retired on the death of Randle III in 1861.

The Victorian garden

Like Sibylla, Sibella was an enthusiastic gardener whose designs may still be seen at Rode today. Indeed, a passion for gardening must have been in the Egerton blood as earlier in the Victorian period Sybilla's nephew, Rowland Egerton Warburton, had planted the impressive double herbaceous borders, thought to be the first in England, at Arley Hall in Cheshire. Another niece, Maria, had created with her husband, the distinguished horticulturalist James Bateman, the famous 'eclectic' gardens at Biddulph Grange only a few miles from Rode. These gardens, together with Sibella's work at Rode, were to inspire Ada Constance

99. A view of Rode's walled kitchen garden as it is today.

Bootle Wilbraham (1842–1917) who, following her marriage to Onorato Caetini, 15th Duca di Sermoneta, created the famous gardens of Ninfa, south of Rome, where English roses scale Italian cypresses in the romantic ruined village.

It was not until late Victorian times that the English gentry actively participated in gardening themselves, rather than merely instructing their staff, and Sibella was probably the first of the Wilbraham wives to pick up a trowel! Fortunately, she had plenty of help from garden boys who, as her own niece remembered, would often 'work for no wages, so great was the privilege of getting into a good garden.' John Bailey, the eldest son of Rode's Keeper, was one such boy who eventually rose to become head gardener and with him she developed the walled kitchen garden so beloved of Victorians (Fig.99). This two-acre plot provided the Wilbraham family, its servants and house guests with plentiful supplies of fresh vegetables and fruit, including grapes grown in a glazed vinery. The building of a simple Gardener's Cottage in the south-facing wall of the kitchen garden allowed John Bailey to keep a watchful eye both on his plants and on the bothy, a small building in the far corner where the garden boys lived. One of their jobs was to stoke the chimneys in the kitchen garden wall which supported the espalier fruit trees. A pathway behind the west wall was subsequently known as the 'Colonel's Walk' by the Wilbraham family who used it to walk to and from All Saints' Church.

Sibella's most significant contribution to Rode's gardens was undoubtedly the planting of snowdrops in the Wild Garden. Brought from Sibella's home, Gresford, the small white flowers had 'spread all over the Old Wood' by the time Katharine was writing her memoir and today provide a major attraction in the annual life of the gardens at Rode. In contrast with this informal, naturalistic planting, Sibella also laid out shrub borders and in c.1861 employed William Andrew Nesfield (1793–1881), well known for his combination of elaborate eighteenth-century parterres and modern plants, to design the terrace and rose garden at Rode.

Peacocks and pottery: Walter Crane at Rode

Nesfield's design was captured, a decade after its completion, in a small chalk and watercolour painting entitled 'Bluebeard and Gloriana'.[86] (Fig. 100) This quietly stylised composition, acquired by Sir Richard for Rode some years ago, was painted by Walter Crane (1845–1915), a key figure in Britain's Arts and Crafts movement which, in reaction to mass industrialisation, encouraged traditional handcraft methods of manufacture.

Muted grey-greens on the horizon of Crane's painting suggest the sweep of Rode Pool as depicted in Repton's Red Book of 1790; bluish yew hedges and pale terracotta urns in the middle-distance evoke

100. 'Bluebeard and Gloriana', painted by Walter Crane in 1871, showing the view from the terrace at Rode Hall. Watercolour, bodycolour and coloured chalks (length approx. 17 ½ in, 44.5 cm).

Nesfield's rose garden; whilst in a flattened foreground, the terrace outside the Doric-columned portico provides a natural stage for the eponymous peacocks, 'Bluebeard and Gloriana', whose heir still stalks Rode's grounds. The patrician plumage of the larger bird stands in contrast to the drab feathers of the impudent little sparrow in the foreground of the picture, a suggestion perhaps of Crane's future interest in socialism. Prominent in the painting and emphasising its Japonisme are two pieces of the Wilbrahams' oriental blue-and-white china, of the sort which was to charm such Victorian artists and aesthetes as Whistler, Rosetti and Wilde. The porcelain also reveals Crane's own interest in ceramic decoration instigated by his visits to Rode during the late 1860s.

Walter Crane was known to Randle and Sibella through his Cheshire-born father, Thomas, who had painted several Egerton family portraits. With the great expansion in mass publishing, Walter Crane had sensibly trained as a draughtsman with the renowned London wood engraver W J Linton and by the early 1860s was earning a small living producing black and white illustrations for newspapers, magazines and books. In 1865 he was commissioned to undertake colour work for the sixpenny and shilling series of Toy Books, printed by Edmund Evans for Routledge, which were to establish his enduring reputation as a

Victorian Arts and Crafts at Rode 105

children's book illustrator. Although painting remained a lifetime passion, Crane's poetic and romantic subjects, inspired by Burne-Jones and fifteenth-century Italian painting, brought only limited public success. The Royal Academy rejected all but two of his paintings but their acceptance in 1862 of 'The Lady of Shalott' ensured that it was as a promising young artist and illustrator that Walter Crane was first welcomed by the Wilbrahams to Rode.

Crane's published autobiography and private diaries suggest that the earliest of his evidently enjoyable visits was in September 1866. His conversion to socialism was then nearly twenty years away but Crane was already interested in political reform and eager to observe the 'country-house' views of his host, Randle, 'a fine specimen of an English country squire and county magistrate' and hostess, Sibella, 'a charming lady of artistic tastes, and herself an amateur of some skill and feeling.' It was she who undoubtedly suggested places nearby for Crane to sketch and paint: by Rode Pool; in meadows by the newly built All Saints' Church, and in the courtyard of Little Moreton Hall.

Sibella quickly established a creative – and professional – collaboration with Crane; his diary for January 1867 recorded that he was sent a manuscript for a children's story entitled *Chattering Jack*, written by 'Mrs W', together with a dead magpie from Rode to help with its illustration. (Fig.101) In this latter endeavour, Sibella was most probably assisted by her footman, Dick Heath, a keen naturalist, from whom, so her niece reported, she learnt much about 'local bird lore'. Published later that year by Routledge as No.64 in their Sixpenny Toy Series, *Chattering Jack* was also available on linen for one shilling. Today,

101. The original manuscript of *Chattering Jack*, written by Sibella Wilbraham in 1866.

102. Copies of *Chattering Jack* at Rode, illustrated by Crane and first published by Routledge in 1867.

examples of each accompany Sibella's original manuscript in the library at Rode (Fig. 102). A note in Crane's 1868 diary suggests that he also sent illustrations to Rode for 'Mrs W's translation of Victor Hugo', possibly a reference to a bookplate designed for Randle Wilbraham's two volumes of Hugo's *Les Travailleurs de la Mer*, also in the library.

It is interesting to speculate on whether Crane's illustrations were inspired by his visits to Rode. With his interest in costume and textile design, he would surely have been enthused by Sibella's collection of shawls.[87] Still surviving at Rode (with examples of early English embroidered costume),[88] these fashionable 'paisley' garments had been sent as presents by Sibella's father and brothers, all of whom were servants of the East India Office in India, then a key colony in the British Empire. The folding Chinese lacquer screen in the library, given to Sibella by her parents as a wedding present,[89] would also have encouraged Crane's bourgeoning interest in oriental art and design. Describing the distinctive style of his picture-book illustrations, Crane was eager to acknowledge the influence of Japanese prints, specifically recalling his first introduction to them at Rode:

> I found no little help and suggestive stimulus in the study of certain Japanese colour prints, which a lieutenant in the Navy I met at Rode Hall, who had recently visited Japan in his ship, presented me with. He did not seem to be aware of their artistic qualities himself, but regarded them rather as mere curiosities. Their treatment in definite black outline and flat brilliant as well as delicate colours, vivid dramatic and decorative feeling struck me at once, and I endeavoured to apply these methods to the modern fanciful and humorous subjects of children's toy-books and to the methods of wood-engraving and machine printing.

103. Tea cup and saucer, Wedgwood Queen's Ware, decorated by Walter Crane in 1866 with allegorical scenes inspired by his visit to Rode that year (Saucer diameter 5 ¼ in, 13 cm).

The success of these new techniques brought Crane commissions '…numerous enough to be put in a separate category and labelled with

104. Detail of Walter Crane's cup showing Cuba, the Wilbraham's pet dog, to the right of the rebus then used by the artist on his ceramic designs.

my name by Messrs Routledge.' The unnamed naval officer Crane had to thank was probably Lieutenant Gubbins who had enjoyed a military career with the Hon. East India Company. Husband of Sibella's sister, Annie, Gubbins was one of numerous relatives and friends of the Wilbrahams whom Crane met for 'tea, croquet, dinner, conversation, song'.

By then, of course, it was customary for afternoon tea and cakes to be taken at five o'clock whilst dinner, as described in publications like Mrs Beeton's 'Book of Household Management', was served between seven and eight. As a fashionable hostess, Sibella would have introduced the new service *à la Russe* at Rode, whereby dinner guests were served each course by servants rather than helping themselves from a selection of dishes on the table. The additional space this provided prompted ceramics manufacturers to produce elaborate comports and table decorations. Like eighteenth-century porcelain, many such tablewares were inspired by natural forms, including one (described later) which was designed by Sibella herself for Wedgwood.

Godfrey Wedgwood, partner at the Etruria pottery from 1859–91, was someone Sibella was pleased to be able to introduce to Crane. The Wilbrahams' continuing relationship with the Wedgwood family had led to Sibella's taking lessons in ceramic decoration from Godfrey's protégé, Emile Lessore, whose painting of Watteauesque subjects on Queen's Ware had earned much acclaim at the 1862 International Exhibition. Sibella eagerly shared her new enthusiasm with Crane who recorded his first experimentation, 'China painting at Rode... The Four Seasons', in September 1866. Shortly afterwards she sent to his London home 'a box with the colours for china painting and a teacup and saucer, Wedgwood Cream Ware.' Decorating the items in a style very similar to Lessore's,

with amorous couples at leisure in a landscaped garden, he posted them to Rode in December 1866.

The cup and saucer must have been returned to the Crane family afterwards for it was only in recent years that Anthony Crane, Walter's grandson, presented them to Sir Richard for display at Rode. On closer inspection, Crane's decoration reveals itself as an allegorical representation of life at Rode: the landscape, with its terrace and urns, is similar to that depicted in 'Bluebeard and Gloriana', whilst the lady playing the guitar is probably Annie Gubbins, the instrument still being in the family's possession at Rode. The dog has also been identified as the family pet Cuba who, together with his companion, Moor, was also immortalised by the Italian artist Enrico Coleman (1846–1911) in his 1867 painting in the staircase hall (Figs. 103–104).

Keen to help Crane in his career, Sibella showed examples of his 'china painting' to Godfrey Wedgwood who, in January 1867, assigned

105. Correspondence from Walter Crane to Messrs J. Wedgwood & Sons, dated January 1867, relating to his first commission to decorate vases in a style similar to those he had painted for Sibella Wilbraham at Rode (Wedgwood MS E31-23877. By courtesy of the Wedgwood Museum Trustees, Barlaston, Staffordshire).

106. A pair of Wedgwood Queen's Ware vases of 'antique' form, painted by Crane in enamel colours, 1867. The subjects represented are, left, 'The Hours' and, right, 'The Seasons' (By courtesy of the Wedgwood Museum Trustees, Barlaston, Staffordshire).

107. A Minton majolica 'Wilbraham tray', designed by Mrs Bootle Wilbraham of Blythe Hall, Lathom, c.1869 (length 8 in, 20 cm).

Crane to decorate a number of vases. The artist took on Wedgwood's commission diligently but with some difficulties, as he familiarised himself with the artistic and economic constraints of designing for a commercial pottery manufacturer. A visit to Wedgwood's Etruria factory in July whilst staying at Rode undoubtedly helped and by the end of a very busy year Crane had delivered the company a number of Queen's Ware trays and 'Antique'-shaped vases which were subsequently shown at the Paris Exposition Universelle of 1867.[90] (Figs .105–106) A further design for a chessboard in 1871 was Crane's last commission from Wedgwood, although his influence as a designer and proponent of handcraft was to be continued by other of the company's artists.

Interestingly, Sibella Wilbraham herself also designed for Wedgwood. She may have been encouraged in this attempt by a cousin, the Hon. Mrs Bootle Wilbraham (Jessy, daughter of Sir Richard Brooke, 6th Bt. of Norton Priory) whose model 'Puck' was produced by Wedgwood in 1870.[91] Mrs Bootle Wilbraham, then living at Blythe Hall near Lathom, had also been responsible for at least two designs for Minton[92] which the company produced in its popular majolica. One model was probably the so-called 'Wilbraham Tray' of c.1869, a small sweet tray modelled as a blue tit perched by an oak leaf, two examples of which have been acquired for the collection in recent years (Fig. 107).

In 1870 Sibella wrote to Godfrey Wedgwood outlining her own design for 'a centre piece for a dinner table – like a vine on which real grapes might be hung.' The idea for the design may have come about whilst sampling some of the grapes grown in Rode's kitchen garden. It was evidently discussed with Walter Crane whose sketch (Fig.108)

108. A small sketch by Crane of the majolica 'Grape Stand for Dessert', designed by Sibella Wilbraham for Wedgwood in c.1870 (Wedgwood MS E31-23891. By courtesy of the Wedgwood Museum Trustees, Barlaston, Staffordshire).

Sibella enclosed, adding: 'I ought to add that Mr Crane is getting on very well and has plenty of employment so there is not the slightest reason to take his sketch unless you really think it will be useful.'[93] But it seems that Wedgwood did, a Majolica Pattern Book recording two shapes under the description 'Grape Stand for Dessert'.[94] Crane made his sketch of Sibella's design during his last recorded visit to Rode in November 1870. The following year, as he set off on his honeymoon to Italy (with a 'sheaf of introductions' from 'my old friends the Wilbrahams'), Sibella died aged only fifty three. It seems that afterwards Crane lost close contact with the family but wrote warmly of the encouragement and influence the Wilbrahams had brought to his early career.

In the following decades Crane's name became universally known, not only as a book illustrator but also as a commercial and interior designer for manufacturers of greeting cards, calendars, wallpapers, textiles, glass and ceramics. The Victorian enthusiasm for practical and decorative tiles prompted pottery manufacturers, including Minton's China Works and the Shropshire firm of Maw & Co, to source or adapt Crane's Toy Book illustrations, usually nursery rhyme characters, for reproduction on their 'picture tiles'. Examples of two such tiles by Minton have been acquired for Rode's collection (Fig. 109).

109. Dust-pressed tile, made by Minton's China Works in c.1880–85, hand-painted over a transfer print adapted from Crane's 1877 illustrated children's book Baby's Opera, *A Book of Old Rhymes with New Dresses* (height 8 in, 20 cm).

Occasionally Crane was asked to produce exclusive designs for ceramic manufacturers. Maw & Co requested designs for tiles in c.1876 as well as a series of seven vases in c.1889.[95] Appropriately enough for a friend and illustrator of Oscar Wilde, Crane's design of the patterns and shapes of the vases reflected the English Aesthetic style whilst their subject matter was inspired by legends and folk tales. A Grimm's fairy tale was depicted on the large bulbous-shaped vase inscribed 'Six Swans', whilst Hans Christian Andersen is a possible source for the cup-necked globular vase decorated with a mermaid. Although Crane's 1888 visit to Greece suggests a Hellenist influence, Norse mythology may have informed his imagery, perhaps prompted by the translation of Icelandic saga by another friend, William Morris. This is best illustrated in the two-handled vase inscribed with the Nordic drinking toast 'Skoal', others being the elaborate swan-shaped vase decorated with an oarsman; the ewer featuring a sailing ship, and the oviform vase encircled by standing robed women. All were made from a coarse earthenware and decorated with variously coloured lustre glazes, revived by

110. The set of six Maw & Co vases by Crane now at Rode, earthenware, painted in ruby lustre glazes on a cream ground, c.1890–91. Top, left to right: cup-necked 'mermaid' (sometimes called 'divers') vase; swan-shaped vase with oarsman; two-handled 'skoal' vase; bottom, left to right: ovoid vase with standing women; bulbous-shaped 'Six Swans' vase; ewer with sailing ship (tallest 13 in, 33 cm).

(the Victorian potter William) de Morgan and commercialised by such firms as Maw & Co. Examples of the seven Maw & Co vases were shown in 1890 by the Arts and Crafts Exhibition Society (founded by Crane, its first president) and again at the World's Columbian Exposition in Chicago in 1893.[96]

Six of the seven Maw & Co vases, decorated with a superb ruby lustre on a cream-coloured ground, are now displayed in the entrance hall at Rode (Fig. 110). A certain serendipity led to their acquisition by Sir Richard from their owner who had reluctantly decided to part with the six; the thirty years he had spent in their collecting is testament to the designs' rarity and desirability. Even without the elusive seventh square-handled vase, decorated with figures representing the Four Seasons, those at Rode form the most complete set in a private collection. The Nordic influences in some designs have special significance for Sir Richard's Norwegian-born wife, Anne, whose portrait in national dress by Norman Hepple hangs close by the vases. The collection of Crane's ceramics is given extra resonance by its context at Rode, where Randle and Sibella Wilbraham provided the young artist with important and influential contacts and where his early experiments with the art of 'china painting' resulted in his first professional commission from a pottery manufacturer.[97]

Others of Crane's contemporaries who visited Rode include the polymath and painter Robert Bateman (1842–1922), son of James Bateman of Biddulph Grange and husband of Caroline Octavia Howard (previously the wife of Reverend Charles Philip Wilbraham); the Cheshire-born illustrator Randolph Caldecott (1846–86); and the French-born British artist Alphonse Legros (1837–1911) whom Crane recommended to paint the full-length portrait of Randle Wilbraham IV which now hangs in the library at Rode. For sixteen years following Sibella's death, Randle was cared for by his footman, Dick Heath, and his wife, Mary, Rode's cook. He died in 1887 and was buried next to Sibella in the crypt of All Saints' Church. The marble reredos representing Lenoardo da Vinci's 'Last Supper' was installed to their memory.

General Sir Richard Wilbraham KCB (1811–1900)

Young Randle had no sons and on his death Rode passed to his half-brother, General Sir Richard Wilbraham KCB (1811–1900) who had married Sibella's sister, Elizabeth Frances Egerton (d.1849). Whilst Randle had lived quietly in the Cheshire countryside, Richard spent much time overseas. He and his elder brother, (later Reverend) Charles Philip Wilbraham, who were schooled in Switzerland, both travelled widely, recording their experiences in diaries, journals and sketch books. The brothers subsequently became published authors and illustrators, Charles of *Scenes Beyond the Atlantic* in 1848, and Richard of *Travels*

111. A photograph of General Sir Richard Wilbraham KCB (1811–1900) taken during the Crimean War of 1854–56.

in the Trans-Caucasian Provinces of Russia, in 1839, which covered his journey as a young army captain from Tehran to Caucasus.[98]

During the early 1850s, when Richard's regiment was stationed at Portsmouth, he became associated with an influential group of writers, intellectuals and religious thinkers living in and around Winchester. Notable amongst these was the Rev. John Keble (1792–1866), founder of the Oxford Movement. A tribute to Keble compiled in 1871 included essays by other members of the social circle: the popular novelist Charlotte Yonge (1823–1901), best known for *The Heir to Redclyffe*, and Frances M Wilbraham, sister of Richard and Randle, also a writer.[99] Richard Wilbraham went on to give distinguished service in the Crimean War (1854–56), (Fig.111) after which time he was employed as Governor General of Woolwich Hospital and as Commandant of the new military hospital in Netley where he worked (not always happily) with Florence Nightingale. He retained his interest in travel in his latter years, writing a memoir of his return visit to North America in 1876.

General Sir Richard was seventy-six years old and living in Norfolk Crescent, London, with his only daughter, Katharine, and her husband, George Barrington Baker, when he inherited Rode in 1887. In Cheshire he continued to lead an active life, his public duties including serving as High Steward of Congleton. Owing to the agricultural depression of the late nineteenth century, many country houses lay empty or had to be sold off; in 1895 the National Trust was founded specifically to save threatened buildings and the open spaces of the countryside. Fortunately, General Sir Richard was able to maintain Rode and during the thirteen years of his tenure he implemented a number of practical improvements to the house and estate, reorganising the drainage, restoring the stables to their original red brick and in 1896 refurnishing the hitherto little-used drawing room.

Survived by his daughter, the death of General Sir Richard Wilbraham in 1900 brought to an end Rode's unbroken inheritance through the male line. His life is commemorated in a brass eagle lectern presented by the family to All Saints' Church, Odd Rode, where a stone rosette from the Church of St Vladimir also provides a memento of his service in the Crimean War.

CHAPTER FIVE

The last century

THE TWENTIETH CENTURY was to see many changes at Rode but, until 1980 when Sir Richard Baker Wilbraham inherited the estate, it was to be a lean time for the ceramics collection. Custodians in 1900 were General Sir Richard Wilbraham's only daughter, Katharine Frances (1849–1945), and her husband of twenty-eight years, Oxford-educated barrister, George Barrington Baker (1845–1912), who was to inherit the title in 1911, becoming the 5th Baronet, Baker of Loventor in Devon.

It was in 1900, on the death of Katharine's father, that George Baker assumed under Royal Licence the principal surname Wilbraham. He was the second male in the family, after Richard Wilbraham Bootle, to have taken his wife's name. And just as the name Bootle had brought additional esteem – and considerable assets – to the Wilbraham family in the eighteenth century, so, too, did the name Baker in the 1900s, for, like Mrs Bootle, George Baker had distinguished and prosperous forebears. Most notable amongst them was his great grandfather, Sir George Baker, 1st Bt. (1723–1809). Although best known today as physician to 'mad' King George III, his medical research was to have indirect consequences for ceramics manufacturers, such as Wedgwood.

Sir George Baker

The son of Reverend George Baker of Modbury in Devon, later Archdeacon of Totnes, Sir George Baker was created 1st Baronet, Baker of Loventor in Devon, in 1776 (Fig.112). He was educated at Eton and King's College, Cambridge, where he received an MA in 1749 and a Doctor of Medicine in 1756. The following year, he was invested as a Fellow of the Royal College of Physicians whose members were to elect him President a total of nine times between 1785 and 1795.

Detail of 'Breakfast at Rode' (see Fig. 120, p. 127).

112. A portrait of Sir George Baker, 1st Baronet and physician to George III during his first attack of madness.

Although medicine was his vocation, Sir George was also a renowned classics scholar and poet, as well as a man of taste and wit. In London, his literary associates included Oliver Goldsmith and Thomas Gray whose poem 'An Elegy Written in a Country Churchyard' was – according to *The Gentleman's Magazine* – dedicated to him whilst a student at Cambridge. He was also a close friend of Sir Joshua Reynolds whose painting of Jane Morris, Sir George's wife, is now at Rode together with Reynold's self-portrait given to Sir George on the artist's death by his niece, Maria Palmer. She then wrote: 'It is the only original I have to give and you are the only person to whom I could give it.' Sir George was elected a Fellow of the Society of Antiquaries and in 1762 of the Royal Society. At that time he had not yet moved to his Jermyn Street, St James's address but lived in Bloomsbury Square, home later in the decade to the Wilbraham Bootles.

If not personally acquainted, Richard and Mary Wilbraham Bootle would certainly have known of Sir George Baker from parliamentary debates and newspaper reports, as the physician who had first noted and treated the initial stages of George III's mental illness in 1788. His diaries and notebooks, which together with the King's own notes on his symptoms are now at Rode, provide a fascinating insight into his predicament. Paid a total of £1380, 30 guineas per consultation, Sir George initially recommended regular spa treatments. However, he later came to the private conclusion that such 'spasmodic derangement of the understanding' could only be cured by complete 'retirement from official duties... at his favourite place of residence'. Not daring to 'communicate [his] suspicions or take any decisive measures in consequence of them', his pessimistic outlook was to cost him the Queen's support and at the time of the King's later bouts of illness he was replaced by other, less sensitive, physicians.

Although primarily remembered today for his role in the regency crisis, Sir George is also known for his earlier discovery of the cause of 'Devonshire Colic'.[100] The illness, common to Devon and certain other areas of the West of England, was previously believed to have been caused by acidity in the cider drunk in those regions. However, Sir George identified the true cause of the colic as the contamination of cider by lead which was then frequently used to line vats and presses. Whilst his treatise on this subject, published in 1767, was to become accepted wisdom and led to the eradication of the disease by the early 1800s, his hypothesis initially caused much debate.

Although cider makers and the medical profession were the chief participants in the exchanges, porcelain and pottery manufacturers were also, directly and indirectly, involved. In support of his original thesis, Sir George Baker quoted the medical observations of Dr Wall, founder of the Worcester Porcelain Factory, whilst in 1768 an opponent, a Plymouth surgeon, obtained chemical analyses from William

Cookworthy who was then applying for his patent to manufacture hard-paste porcelain.

That same year also saw another publication by Sir George in which he claimed that the lead glaze used on modern earthenware might be dangerous to those eating or drinking from it.[101] Amongst the reports which followed was one which specifically identified traces of lead in examples of Wedgwood's Queen's Ware.[102] Whilst this understandably caused concern to Josiah Wedgwood, he seemed to bear no ill will against Sir George Baker whose name was included on the list of portrait medallions in Wedgwood's first Ornamental Ware catalogue of 1773. Sir George was the first to spark the debate regarding the potential dangers of lead-glazed earthenware for the eighteenth-century consumer, the real hazards to potters' health having been established some twenty years earlier. It was a debate which was set to continue and indeed was still persisting in the Potteries at the time his great grandson George Baker was resident at Rode.

The early 1900s

By the early 1900s, very few of England's earliest pottery and porcelain factories were still in operation. In north Staffordshire, firmly established as the country's foremost area of ceramics production, declining trade, both at home and overseas, saw many businesses struggling to survive. Principal potteries still existing from the eighteenth century were Wedgwood, then known as Josiah Wedgwood & Sons Ltd; its old rival, Adams; Spode, then trading as W T Copeland & Sons, and Minton. London still remained the main market for ceramics but had few major manufacturers, an exception being Doulton & Co which maintained its original Victorian stoneware works in the capital whilst also operating a successful china and earthenware works in the Potteries. Elsewhere in the country, Dr Wall's Worcester factory had continued, through its various partnerships, to become the Worcester Royal Porcelain Company Ltd; the Derby King Street Works, later to be taken over by Royal Crown Derby, maintained trading as Stephenson & Hancock, and Coalport overcame a period of uncertainty to successfully revive its fortunes under Art Director T J Bott.

Although technical advances continued to change methods of production, traditional styles remained popular in the early 1900s. Those potteries surviving from the eighteenth century were able to draw on their past heritage by reviving past products: oriental-style patterns, especially Japanese Imari; Neo-classical Adams-style designs with swags and cameos, and pretty Sèvres-style floral patterns. Some new stylistic influences were also evident at that time. The serpentine asymmetric designs of Art Nouveau, for example, which were first demonstrated by the English illustrator Aubrey Beardsley during the 1890s, were

113. Wedgwood blue Jasper (top), a covered vase with bas-relief decoration of Flaxman's 'Dancing Hours', and (bottom) a pair of Barber bottles, shape 1110, decorated with his designs of 'The Seasons', c.1900 (tallest 10 ½ in, 27 cm).

adopted by commercial potters in the early 1900s. So, too, were the bright glazes previously favoured by Arts and Crafts studio potters, as demonstrated by the six ruby lustre Maw & Co vases by Walter Crane at Rode.

George Baker's diaries suggest that as a young man his wide cultural interests also extended to ceramics.[103] During 1871 he made several visits to the International Exhibition in London where, on payment of 1s entrance fee and 6d for refreshments, he viewed 'the Porcelain and Potteries'. He also made a special visit in 1875 to see 'Mr Gladstone's China etc on view at Christy's [sic]', a reference to the British Prime Minister whom Katharine's father, General Sir Richard, met on several occasions. Prior to their first 'house warming tea party', George and Katharine 'went to Goode about the china', Goode being the prestigious London retailer, Thomas Goode & Sons, whose mark appears on several late nineteenth-century services in Rode's china cellars. Amongst other china stored there are utilitarian oval meat dishes from the late 1890s bearing the family crest and motto IN PORTU QUIES; they were purchased not from Goode's but from Soane & Smith of Oxford Street whose mark accompanies that of the plates' manufacturers, Bishop & Stonier Ltd. of Hanley in the Potteries (1891–1939).

Although the three decorative Jasper vases displayed in a bedroom at Rode all featured in Wedgwood's '1878 Illustrated Catalogue of Ornamental Shapes', their impressed marks indicate that they were acquired in c.1900 when such Neo-classical designs were enjoying something of a revival. Wedgwood's celebrated modeller, John Flaxman Jnr (1755–1826), was responsible for the original allegorical bas-relief designs: 'Dancing Hours' represented the Horae or hours of the day on the single covered engine-turned vase; while 'Seasons' were depicted on

114. Utilitarian items from Wedgwood: a Queen's Ware toilet set, decorated with the print and enamelled pattern, 'Vine', c.1903–06 (height of jug 8 in, 20 cm).

115. A two-handled oval covered tureen of rococo-revival shape, decorated with a crested foliate scroll-work pattern in iron red and gilt. One of a number of tureens from a large dinner service made by Coalport for Sir John Hutton Cooper in c.1825. The service was bequeathed to the Baker family on the death of his widow, Maria Cooper (length 14 ½ in, 37 cm)

the pair of tri-coloured Barber bottles (Fig.113). More prosaic but no less appealing are the Wedgwood 'toilet sets' which were acquired in c.1905, shortly before Rode enjoyed the luxury of its 'en-suite' wash-basins and four new bathrooms. Mahogany wash stands still hold Queen's Ware jugs, basins and other accoutrements, including a beaker and lidded trinket box, all decorated with the Art Nouveau 'print and enamel' pattern, 'Vine' (Fig.114).

Undoubtedly the greatest ceramic legacy George Baker left to Rode was the impressive Coalport dinner service decorated with the crest of Sir John Hutton Cooper (1765–1828). A medical doctor of Bath, Sir John also served as Groom of the Bedchamber to the Duke of Clarence (later William IV). His third wife was Maria Charlotte, daughter of physician Sir George Baker, and it was she who bequeathed the Coalport service, amongst the contents of her homes in London's Grosvenor Square and in the Royal Crescent and the Circus in Bath, to George Baker's father in 1840.[104]

The elaborate rococo-revival shape of the service, with its moulded dentil 'Gadroon' edge and distinctive asymmetrical knops, was intro-duced at Coalport in c.1820. The date suggests the service may have

been produced either for Sir John's marriage to Maria in 1821; his election as MP for Dartmouth in 1825; or on receipt of his baronetcy, 1st Baronet, Cooper of Walcot in Somerset, in 1828. Coalport's usual impressed numeral '2' appears on some items, together with the pattern number 952 neatly written in either red or gold. The highly decorative foliate scrollwork pattern, in red enamel and gilt (but without an armorial crest) is illustrated in John Rose's factory pattern book, now in the ownership of the Wedgwood Museum. Rode's service is still sizeable, comprising dinner plates; serving dishes of various shapes and sizes; soup tureens and plates; sauce tureens and stands, and a fruit bowl (Fig.115). There is further evidence of Spode's provision of 'matchings' in two rectangular tureens, a factory pattern book indicating that the company also produced the same design on Gadroon shape tea wares in c.1824.[105]

The Coalport service was only part of his family inheritance George Baker brought to Rode. Amongst other significant items were Maria Cooper's silver model of the 'Warwick Vase', an 1820 copy of the Roman original given by Sir William Hamilton to his nephew the Earl of Warwick, and the Baker family's very fine library previously housed at No. 4 Hyde Park Square in London. Not only did the library include Sir George Baker's medical books and manuscript papers, but also a collection once belonging to the sculptress Mrs Anne Seymour Damer (1749–1828), the niece of Horace Walpole whose house at Strawberry Hill she inherited. Amongst her books was a First Folio of Shakespeare which, sadly, was amongst other valuable volumes sold off by the family in 1906. The library sale was notably included as a detail in *Clayhanger*, a 'Five Towns' novel of 1910 by the Potteries-born author, Arnold Bennett (1887–1931).[106] Writing in the English Realist tradition, he would doubtless have appreciated that the funds raised by the sale were spent on the installation at Rode of new plumbing and heating systems.

116. Portrait of Sir Philip Baker Wilbraham at Rode, a copy of that painted by Oswald Birley in 1940 for Church House in Westminster.

Spanning the Wars

George Baker was succeeded by his younger and only surviving son, Sir Philip Wilbraham Baker Wilbraham (1875–1958). Born at Rode, the young Philip proved to be an outstanding scholar. From Harrow, where he was head of the school, he went up to Balliol College, Oxford, gaining degrees in classical studies, philosophy and law, before his election in 1899 as a Fellow of All Souls. He was called to the bar by Lincoln's Inn in 1901, the year of his marriage to Joyce Christobel (d.1958), only daughter of the politician Sir John Kennaway. During the years before he was elected a bencher in 1942, he established his reputation as an eminent ecclesiastical lawyer and administrator. Of his many appointments, he was at some time Secretary of the Church Assembly; Dean of

the Arches, serving as judge of the country's highest ecclesiastical court; and First Church Estates Commissioner (Fig.116).

Although much of his work had kept him in London, Sir Philip continued the duties concomitant with tenure of Rode, as High Steward of Congleton from 1912 and JP for the county of Cheshire from 1919. Between those years, like many large country houses, Rode was used as a Red Cross hospital in the First World War. (Fig.117) Although Sir Philip was later to note that the money from the Red Cross committee was 'just about enough to pay for a new cloth and cushions on the billiard table', at the time of the hospital's opening in April 1917, he said: 'There are a good many drawbacks and difficulties but one couldn't possibly let the house be unused if it is really wanted.' Organised by the Odd Rode Voluntary Aid Detachment, the forty-five-bed hospital was efficiently run by an all-female staff, headed by its commandant, Mrs Katharine Ffoulkes, sister of Sir Philip and the wife of the Rev. Piers John Benedict Ffoulkes, Rector of All Saints' Church. A total of 550 men were treated there, cheered up no doubt by the company of the hospital dog, Jock! One nurse, recounting Armistice in 1919, commented: 'We had a regular beano, were drinking champagne at night [at] Sir Philip's wish.'[107] The comment would appear to be fair; although Sir Philip was a shy and deeply religious man, presiding over family prayers each morning, he was also very friendly and hospitable, reputedly losing 'his reserve in the Athenaeum billiard-room.'[108]

Although Sir Philip had implemented a scheme of improvements at Rode, family funds were modest. His conscientious and practical efforts stood in sharp contrast to the legendary extravagance at play at Lathom Hall, then owned by the 3rd Earl of Lathom, Edward William Bootle Wilbraham (1895–1930). A theatrical dilettante, Ned Lathom, as he preferred to be known, sponsored many West End and provincial pro-

117. Patients and nursing staff at Rode during the First World War when the house was used as a Red Cross hospital.

ductions during his short life and was the first patron of Noel Coward. Although six of his rather risqué plays were published, the Earl's own attempts as a playwright met with only limited success. At Lathom he lavished hospitality on such luminaries of the Roaring 'Twenties as Ivor Novello, Mrs Patrick Campbell, Gertrude Lawrence and Gladys Cooper. The high jinks of his fast set were said to have caused the destruction of a costly and elaborate glass staircase he had installed at Blythe Hall on the estate. In the end, Ned Lathom's profligacy caught up with him and he was finally forced to sell Lathom in 1923. The contents of the hall, which was partially demolished later in the 'twenties, were sold, either privately or at auction, whilst most of the family papers are thought to have been burned in the furnaces at nearby Blaguegate Colliery.[109] Amongst family heirlooms dating back to the Bootles' first proud occupancy of Lathom 200 years earlier was Thomas Bootle's delftware punch bowl. Dying bankrupt in a St John's Wood flat, the Earl's last words, to actress Marie Tempest, were reputedly: 'How lovely it is to be without possessions.'[110]

This sentiment is one which has never been promoted by ceramic manufacturers! Indeed, when households shrank following the First World War, they desperately sought substitutes for the multitude of domestic kitchen wares, formal tablewares and large decorative items they had supplied in Victorian and Edwardian times. As an economic recession began to hit Britain during the early 1920s, potters chose to concentrate on mass-produced inexpensive wares. Slip-cast in plaster of Paris moulds and either transfer-printed, simply enamelled or brightly glazed, such items were designed to suit the lighter, less cluttered interiors of small newly built houses. The modern, brightly coloured, geometric patterns of Art Deco, so-named after the *Exposition Internationale des Arts Décoratifs et Industriels Modernes* held in Paris in 1925, soon found favour with a fashion-conscious middle class which no longer aspired to imitate the customs of the country gentry. However, ceramic manufacturers, especially the illustrious eighteenth-century ones, continued to produce, though on a reduced scale, the traditional, hand-painted and gilded china wares which many of the wealthy upper classes found more appropriate for their country houses.

The utilitarian role which Rode had assumed during the First World War meant that any ceramics purchased were of necessity practical rather than ornamental. Nonetheless, Lady Baker Wilbraham was evidently appreciative of Rode's existing porcelain, receiving information on the collection in 1919 from Harry Barnard (1862–1933) who as well as providing assistance to the Wedgwood Museum was also a significant designer for the company. Although Sir Philip's priority at Rode was to continue the scheme of maintenance and modernisation begun by his father, neither appears to have considered funding it by the sale of any of the ceramics collection. Instead, finance was raised by the sale of the

estate's outlying properties, including in 1923 Mow Cop Castle and its surrounding land. By then, improvements had included the re-roofing and re-drainage of the house, a new water supply, improved plumbing and central-heating systems, the building of two new lodges and a number of cottages, and the installation of electric lights. An example of Sir Philip's continuing pragmatism was his acceptance of bathroom tiling as a silver wedding present (the offer being made by Colonel Harry Johnson of Boden Hall, owner of the ceramic tile company H & R Johnson Ltd)!

Yet in spite of the best efforts of Sir Philip, there was still much to be done at Rode. Further interior redecoration was essential whilst the stained and peeling stucco and now quaint *porte-cochère* made the exterior appear dingy and unwelcoming. Then, in 1926, as the rest of Britain was in the grip of a recession, there came good fortune as the family found itself the recipient of a £5,000 legacy. It came from an unexpected source: Beatrix Tollemache (1840–1926) whose love for an older man, Rev. Charles Philip Wilbraham, (Sir Philip's great uncle), had been thwarted by her father, William, Lord Egerton of Tatton. Claiming that 'no 23-year-old woman can know her own mind', Lord Egerton had withheld consent for the couple to marry but Beatrix had never forgotten Charles nor indeed Rode, stipulating that her legacy should conscientiously be spent on 'keeping up the old family house'.

The family was more than happy to fulfil this last and poignant request. When a local architect, Scrivener & Sons of Stoke-on-Trent, found the commission to restore the house too ambitious, the Baker Wilbrahams employed in 1927 the London architect Darcy Braddell (1884–1970). Although Braddell was recommended by the Colegate family of The Pole in Nantwich, he had a few years earlier worked on Winnington Hall in Northwich, the Cheshire home of Ludwig Mond, founder of Imperial Chemical Industries. During his conversion of the house into a country club for Mond's workers, Braddell commissioned for its gallery fifteen large Wedgwood Black Basalt vases, six of which are now in the Wedgwood Museum at Barlaston, Staffordshire.

Braddell's appreciation of Neo-classical design informed both his radical modernist interiors, such as the drawing room of Mulberry House in London (the Lutyens home of Mond's son, Lord Melchett), as well as his more restrained, traditional schemes, such as the restoration of Rode. Externally, at Rode, Braddell removed Hope's stucco, exposing the house's original warm-red Cheshire brickwork, and replaced 'St Pancras', its shabby *porte-cochère*, with a smart Ionic portico. He continued the understated classical elements into the calm, columned entrance hall, where Sir Philip's beloved billiard table, perhaps in contradiction to Braddell's wishes, still provided entertainment at Rode's shooting parties. 'His gifts are artistic rather more than practical,' Sir Philip was to write of him, 'but he entered into all our ideas with ready

sympathy, and with a strong impression of the house and its possibilities. Moreover he was always good company.'

Post-war developments at Rode

Sir Philip was succeeded in the baronetcy in 1956 by his only son, Sir Randle John Baker Wilbraham (1906–80). Educated like his father and grandfather at Harrow, Sir Randle graduated from Balliol College, Oxford in 1928, marrying Betty Ann (Torrens) two years later.

Although a land agent by profession, Sir Randle's interest in land management did not apparently extend to Rode's gardens which had been in sorry decline since his parents' day. With young garden boys away serving king and country during the First- and Second World Wars, the garden continued to suffer neglect. The kitchen garden had been initially maintained, with Sir Philip serving as Chairman of the '1st Annual Show of Vegetable, Fruit, Flowers and Produce' held at the Tenants' Hall in 1919, but only in the summer when the family returned to Rode from London did the head gardener set about preparing the rest of the garden for the usual round of tennis parties and teas. There was some restoration of the Wild Garden during the 1930s but under Sir Randle's subsequent tenure it grew wilder still, with Rode's sole gardener-cum-factotum mowing the long grass with a tractor just once a year. By the 1970s the kitchen garden was once more in decline, the plot given over entirely to Christmas trees and pheasants and its walls and greenhouses left to languish in a state of disrepair.

Sir Randle's *laissez-faire* approach to horticulture was in contrast to the meticulous schemes implemented by his wife, Betty, in Rode's formal

118. 'A is for Apples': two of Rode's well used 'Alphabet' nurseryware mugs. 'Adams England' printed mark (height 2 ¾ in, 7 cm).

119. 'To work in the garden is ever such fun… ': a pewter-based warming dish printed with an appropriate children's illustration by Mabel Lucie Attwell, 1920s (diameter 8 in, 20 cm).

gardens. During the 1950s there was a renewed national interest in gardening, encouraged by post-war radio and television programmes, and garden visits again became popular. The rose became the flower of choice, supplied by specialist rose breeders. One, Hilda Murrell of Shropshire, supplied the then popular shrub roses for the new 'L'-shaped herbaceous borders at Rode. She also assisted Lady Baker Wilbraham in her redesign of Nesfield's rose garden. The plan, the basis of which still remains, involved replacing the poles and ropes, on which its original roses were entwined, with a star-shaped central bed. Around the old Victorian garden urn in its centre (since replaced by a contemporary bronze statue) were planted Queen Elizabeth II roses whilst the two crescent-shaped beds on either side were filled with Peace roses, a breed which had arrived in Britain from France at the end of the war in 1945. Sadly, a lack of funds prevented the completion of all the ideas suggested by the famous plants man James Russell who advised on the planting of the now spectacular rhododendrons in the Wild Garden in the early 1960s.[111]

Fashions in gardening were again reflected in ceramics and the rose became a popular decorative subject in the 1950s, although it was then more likely to be transfer-printed in voguish black and pink rather than painstakingly hand-painted as it had been 200 years earlier. Neither Sir Randle nor Lady Baker Wilbraham demonstrated any particular interest in ceramics. The most pertinent incident of Sir Randle's stewardship was in 1961 when his woodman unwittingly uncovered from the muddy depths of Rode's stew pond a bundle of 'old crockery' (the family's Worcester 'Dr Wall' Blue Scale service, which had been unceremoniously discarded during a daring 'brace and bit' burglary in 1934).[112]

The shelves of china in the butler's pantry at Rode are testament to a love of entertaining, rather than of decorative porcelain. There are few of the streamlined contemporary styles of 1950s, which replaced the plain undecorated 'utility' wares produced for the home market during the Second World War, but a representative selection of the more traditional designs produced by local potteries in the 1960s. A large collection of printed nursery-ware mugs, dating back to the 1920s and '30s, some of which bear patterns and rhymes relating to gardens, suggests that children, too, continued to be entertained well at Rode. The 'Sunday School Treat' in the Park remains a fond memory for many who grew up in the villages of Scholar Green and Rode Heath. (Fig.118-119)

That the family continued to make use of Rode's more distinguished porcelain services is apparent from a family portrait of 1957 in the entrance hall. (Fig.120) Robin Goodwin's 'Breakfast at Rode' depicts the family – Sir Randle and Lady Baker Wilbraham, together with their son, Rode's current custodian Sir Richard, and daughter, Letitia – taking traditional English breakfast in the dining room. On the Gillow table are items from an 1820s Coalport service, still remaining in the china cellars, together with a silver condiment set and cutlery. A cheerful orange marmalade pot, possibly a Carlton Ware example from

120. 'Breakfast at Rode', a conversation piece by Robin Goodwin, 1957.

the 1930s, and a vase of sweet peas, flowers traditionally cut from the kitchen garden by the 'lady of the house', suggest an informality in the elegant surroundings. At a time when many country houses and gardens were being rescued by the National Trust, the portrait conveys a sense of both the privileges and the responsibilities of the country landowner as Sir Randle sits in contemplative mood, looking out on Rode Park; the Land Agents' Journal in his hand and the plan of Rode Hall by his side echo the legal books on tenure and the preparatory ground plan of the house depicted in Hudson's portrait of Randle Wilbraham II behind him.

Although Sir Randle was primarily interested in country pursuits, he also spent considerable time researching and restoring Rode's library. In a 1960 summary of its contents, he described it as a 'typical country house library', its 4,000 books mainly covering literature, history, travel, topography and natural history. Family authors represented were General Sir Richard Wilbraham, Sibella Wilbraham and her sister-in-law, Frances Maria Wilbraham, whom he described as a writer of 'sentimental Victorian novels'. The library's main sources he identified as Sir George Baker whose important collection of medical books and manuscripts were amongst the Baker family libraries brought from No. 4 Hyde Park Square; 'Counsellor' Randle Wilbraham II, whose legal books include the volume of 'Coke upon Littleton' shown on his portrait; Letitia Rudd, first wife of Randle III, who brought with her an extensive family collection of seventeenth-, eighteenth- and a few sixteenth-century books; and Sir Randle's own father, Sir Philip, who contributed over a hundred finely bound books, mainly literature and history, which he had won as prizes at Harrow.

Acquisitions continued with Sir Randle's own purchase of family diaries and account books written by Thomas and Roger Wilbraham of Townsend House in Nantwich during the sixteenth and seventeenth centuries. Family history and the heritage of Rode were especially valued by Sir Randle and in 1973 he published his own research on the family's foundation of 'Dobbs's Chapel'. He was reserved in his assessment of the family's achievements, writing:

> The family have produced no great statesmen or men of letters, no bishops and no great fighting men, but it would be fair to say that with few exceptions, they have served their country with steadfastness and ability in Parliament, in the Army or the Law, and, as good country men, in local affairs against a background of harmony and domestic affairs and love of the countryside and, in particular, the lands which they inherited.

Sir Randle died in 1980 at the age of seventy three and was succeeded by his son, Richard, as 8th Baronet.

121. Rode Hall with February snowdrops.

Rode today

Born in 1934, Sir Richard was educated at Harrow and thereafter pursued a career in investment banking in London before moving to Rode in 1989. Today he continues the restoration and maintenance of Rode his ancestors have often struggled to sustain but reflecting the changing role of the English country house owner, he and his wife, Anne, have become the first generation of the family to subsidise its conservation by welcoming paying visitors. This decision, made with Sir Randle shortly

122. Chinese export porcelain from the kitchen dresser at Rode. (diameter 8½ in, 21 cm).

123. Items from the 'Snowdrop' coffee set, Bridgewater pottery decorated by Sibella Makower, a present to her parents, Richard and Anne Baker Wilbraham in 2001 (saucer diameter 5 in, 12.7 cm).

before his death in 1980, allows many others to share the family's pleasure in their beautiful country house and gardens (Fig. 121).

The early years at Rode were not easy for them as the discovery of extensive dry rot called for urgent restoration of the house but, with guidance and assistance from English Heritage, they set about repairing the damage. As renovation work started at the top of the house, all the most precious family porcelain, which since the First World War had been stored in the attic, was carried carefully down several flights of stairs to the safety of the cellars, where the family had taken shelter during the Second World War! It was to be several years before the original collection of ceramics could be re-displayed with Sir Richard's recent acquisitions.

While work was underway on the house, Anne set about implementing an energetic clearing and replanting of Rode's gardens, successfully returning them to their glorious nineteenth century style. Amongst the mature trees, rhododendrons and ferns in the Wild Garden, Sibella Wilbraham's Victorian snowdrops were encouraged to flourish; some forty different varieties have now been divided and spread down the driveway to greet visitors to Rode's Snowdrop Walks in early spring. Past the stew pond, its bank planted with late-flowering scented azaleas, snowdrops also extend to the boathouse by Rode Pool where wild duck and herons play host to greater crested grebes, kingfishers and the occasional osprey.

The restoration of Rode's walled kitchen garden was a priority for the Baker Wilbrahams and today its espaliered fruit trees are once again thriving whilst the restored greenhouse warms the scented leaved geraniums which were so admired by Victorian gardeners. The efforts of the head gardener are repaid in crops of vegetables, fruit (including over forty cultivars of gooseberry) and flowers, its colourful cornflowers,

124. Two jugs commissioned from the ceramicist Sally Tuffin of Dennis China Works, hand-thrown earthenware with slip-trailed and incised decoration, specially inscribed and dated to commemorate the birthday of Anne Wilbraham in 2000 and 2001 (height 9 in, 23 cm).

poppies and marigolds attracting many butterflies during the summer months. The garden provides enough produce to sell to visitors – the proceeds paying for next year's seeds – as well as supplying the family's own table. Guests continue to enjoy the fine food and hospitality for which Rode has always been noted, though not perhaps incurring the same costs as in earlier years; the total annual expenditure on Rode's 'cellars' in 1802 was £778 12s 5d, over half that spent in the same year on 'repairs and furniture'!

Formal lunches and dinners are still served in Rode's regency dining room using the family's finest china (including on occasions the

125. Sunderland Ware jugs, decorated with pink lustre glazes and black transfer prints of, left, 'A Sailor's Farewell' and, right, 'Northumberland', c.1800–50 (height 7 ½ in, 19 cm).

126. 'Beckoning Chinaman', made in c.1760 by Chaffers of Liverpool, the first teapot acquired by Sir Richard for the collection at Rode (height 6 ½ in, 16.5 cm).

Coalport porcelain). However, today's meals are just as likely to be enjoyed in the comfortable Victorian-style kitchen where a dresser display of eighteenth-century Chinese export porcelain (Fig. 122). looks down on 'Blue Willow', the modern-day pottery it inspired. Although her first passion is for plants, Anne also shares some of her husband's undisputed love of ceramics. She is especially fond, for obvious reasons, of a 'snowdrop' coffee set hand-decorated in lustres by her artist daughter, Sibella Makower. This unique tableware was produced at a Bridgewater Pottery café, a 'DIY' decorating studio initiated by one of Stoke-on-Trent's most enterprising and successful contemporary potteries (Fig. 123).

From her husband Anne has received over several recent birthdays a small collection of ceramic designs specially commissioned from Sally Tuffin of the Dennis China Works. This small pottery, founded in 1993 by the designer and her husband, the specialist ceramics publisher Richard Dennis, operates from the converted stables of a Victorian Gothic rectory in Somerset. Sally Tuffin's designs continue the 'botanical' theme seen in much of Rode's eighteenth-century porcelain, whilst her hand-thrown shapes, incised and slip-trailed, show a commitment to traditional craftsmanship, as demonstrated in nineteenth-century Arts and Crafts Pottery, such as that produced by William de Morgan and Walter Crane. (Fig.124)

In contrasting style is Anne's collection of Sunderland Ware, a type of pottery of particular interest to Scandinavians. Characterised by

black transfer-printed designs framed by 'spattered' and 'splashed' pink lustre glazes, it was made by Dixon, Austin & Co at Sunderland in the north east of England. The pottery was produced in the first half of the nineteenth century when Sunderland, on the river Wear, was the most important ship-building centre in the country (Fig. 122). Consequently, many of the popular and often sentimental prints frequently feature sailing ships, recalling the Liverpool delftware produced a century before in Sir Thomas Bootle's day.

It was an example of Liverpool chinoiserie, a 'Beckoning Chinaman' teapot by Chaffers, which was Sir Richard's first acquisition for Rode's ceramics collection in 1980. (Fig.126) With hindsight, the choice was appropriate, as Captain Robert Bootle's shipments of Chinese porcelain tea wares in the 1730s heralded the family's long-established links with the English ceramics industry. As described, Sir Richard has been able to acquire rare examples of the three Chinese armorial services commissioned in Canton by the Bootle family, whilst his fine collection of rare and early eighteenth-century English porcelain teapots continues to increase, in spite of efforts to the contrary! Today

127. A rare Chelsea open work dish, very finely painted with an extensive harbour landscape scene and daffodil, rose and butterflies to the border, brown enamel rim, c.1754. Red Anchor (length 10 ¼ in, 26 cm).

128. The earliest item of English porcelain at Rode, a rare and important Chelsea sugar bowl and cover, of eight-lobed form, with moulded and coloured flowering tea plants. One of only five known, this is the only recorded coloured example. Raised triangle period, c.1745–49 (height 5 in ,12..5 cm)

the teapots are suitably displayed in the drawing room where the family have entertained guests to tea since 1752, amongst them, Josiah Wedgwood, the country's greatest potter.

As Sir Richard has brought the collection to maturity, he has also initiated research by ceramics experts into the family's earliest collection of porcelain and pottery. Most significant of their finds has been the attribution of the important Derby 'Billingsley' dessert service – which Sir Richard remembers being used by his grandfather! – and the identification of its commission by Mrs Bootle in 1787–88. Mrs Bootle's patronage of English porcelain manufacturers has inspired Sir Richard to collect further exemplary items of Chelsea, Bow, Derby and Worcester. The illustrations in this book are testament to their fine quality which is further enhanced by their setting and display at Rode. The earliest new addition to the collection, dating from c.1745–49, is the rare Chelsea sugar bowl and cover, the only one recorded to date with a colour-decorated tea plant (Fig.128), whilst Sir Richard's personal favourites are probably the delicate landscapes and Fable scenes painted by O'Neale at Chelsea and the beautiful Giles-decorated tea wares (Figs. 129–130). Sir Richard's acquisition of Crane's nineteenth-century Maw & Co vases and the contemporary designs of Sally Tuffin demonstrate Sir Richard's wider interest in ceramics and his family's continuing support of ceramic designers.

In the twenty-first century, even with grant aid, financing the preservation of an historic country house and its gardens remains a challenge for its owners. The Baker Wilbrahams enjoy welcoming visitors to Rode but have ensured that it retains its primary purpose as a family home rather than exploit it as a large commercial enterprise. Therein lies

129. A Chelsea dish with a chocolate-brown rim and fluted border painted with scattered coloured flowers, c.1752–55. The central panel is painted by O'Neale with 'The Sick Lion', adapted from one of Francis Barlow's seventeenth-century illustrations of Aesop's Fables (length 8 in, 20 cm).

130. A rare and elegant Worcester porcelain teapot, decorated in the studio of James Giles, with characteristic flower painting and gilding to the spout and elaborate twisted handle, c.1770–72. Worcester's 'crossed swords and 9' mark in underglaze blue (height 7 in, 18 cm).

its charm. It is perhaps not too fanciful to draw parallels between England's country houses and its ceramics industry; since their rise in the eighteenth century, both have become endangered species, seeing their old dynasties die out and their heritage disappear, either exported overseas or simply lost forever. Fortunately, by careful management and diversification, some English country houses and ceramics manufacturers continue to survive. In Rode, one can observe the best of both.

Notes

CHAPTER 1

1 Family Diary of the Wilbrahams of Nantwich and Delamere in Cheshire, 1513-1962 Cheshire and Chester Archives and Local Studies Service, DDX 210.
2 Of the large estates which the Wilbraham family had amassed in and around Nantwich by the mid-seventeenth century, the senior line was seated at Woodhey and the two younger branches at Dorfold Hall and Townsend House.
3 Townsend House was built by Roger Wilbraham's great grandfather, Richard Wilbraham (d.1601), in Welsh Row, Nantwich, in 1580. The Wilbrahams were resident there for some two centuries but the house subsequently fell into disrepair and was demolished in the 1950s. Today, only the ruins of the Old Walled Garden remain. To preserve this area from commercial development, the Nantwich Walled Garden Society was launched in June 2004. It is supported by the current custodians of Rode, Sir Richard and Lady Baker Wilbraham.
4 Moreton family papers, quoted by Rowell, Christopher, 'Little Moreton Hall' p. 29 (The National Trust 1979).
5 Lake, Jeremy. 'The Great Fire of Nantwich'. Ch. 3, The Gentry, p43, Ref. Cheshire and Chester Archives and Local Studies Service, DDX196 (Shiva Publishing Limited 1983).
6 Nantwich had been a major inland producer of salt from its brine pit since the tenth century. In common with other county families, the Wilbrahams owned numerous salt houses in the town and it was whilst a guest in Townsend House in 1617 that James I witnessed salt manufacture. By that time, the town's salt industry was in some decline. Although there is evidence that the lands surrounding Rode may have offered salt production, the purchase of the estate was more likely made on the guaranteed opportunity for the family to increase its farming interests.
7 A document dated 24 November 1693 records an annuity of £60-00 from the manor of 'Roade alias Oddroade' paid by Roger Wilbraham to 'Stephen his younger son'. Crosse of Shaw Hill Muniments, Lancashire Record Office. DDSH 6/21.
8 In 1626, Thomas Wilbraham, father of Roger, employed a Dutchman to make stained glass windows at Townsend House. Oxford and Lincoln's Inn educated, Thomas Wilbraham travelled widely in Europe and in 1614 published 'Licence to Travel'. He moved to Townsend House, Nantwich, where, as a strong royalist, he entertained James I in 1617. During the Siege of Nantwich, he was imprisoned in his own home. He died in 1642 shortly after the outbreak of the Civil War. Lake, Jeremy. 'The Great Fire of Nantwich', p. 63 (Shiva Publishing Limited 1983).
9 This inventory was made on the death of Roger's great grandfather, Richard Wilbraham, who built Townsend House. It also lists: 'Item ij stone potts bound w(i)th silv(er) w(i)th Cov(er) guilt £2', a description similar to that of the stoneware pots in Roger Wilbraham's will of 1687. The inventory is reproduced in Lake, Jeremy. 'The Great Fire of Nantwich', pp. 161–65 (Shiva Publishing Limited 1983).
10 Defoe, Daniel, 'A Tour through the Whole Island of Great Britain (1724–726)', pp. 162–66 (London 1962).
11 Wilmot. J, 'Life of Sir J E Wilmot', quoted in Sedgwick, Romney 'The History of Parliament, The House of Commons 1715–1754. II Members E-Y', p. 538 (Her Majesty's Stationery Office 1970).
12 The date of 1752 is given in Lyson, Magna Britannia, Vol. 2., p. 492 (1810).
13 In the mid-nineteenth century Mow Cop castle was the subject of a dispute between Randle Wilbraham IV and Ralph Sneyd of Keele Hall who claimed ownership as part of the building encroached on his land in Staffordshire. In 1850 a jury at Stafford Assizes declared joint ownership between the Wilbrahams and Sneyds; each family was to have its own key with a third being kept 'on the hill'. In the 1920s the castle and surrounding land was sold for quarrying but later fell into disrepair. It was bought by the National Trust in 1937.
14 Richard Wilbraham kept very precise records of his purchases for the gardens at Townsend House (see Footnote 3). These documents are now amongst the Wilbraham family archive at Rode.
15 Lord Lyttleton of Hagley Hall in Warwickshire, writing to his architect Sanderson Miller in 1752. Girouard, Mark 'Life in the English Country House'. Chapter 7, 'The Social House', p. 204 (Yale University Press 1978).
16 Reference to this case appears in the publication 'The Percy Anecdotes': 'The spirit of litigation was, perhaps, never carried to a greater extent, than in a cause between two eminent potters of Handley Green, Staffordshire, for a sum of two pounds, nine shillings, and one pence. After being in chancery eleven years, from 1749 to 1760, it was put an end to by John Morton and Randle Wilbraham., Esquires, to whom it was referred: when they deter mined that the complainant filed his bill without any cause, and that he was indebted to the defendant, at the same time, the sum for which he had brought this action. This they ordered him to pay, with a thousand guineas of costs!' Percy, Sholto and Reuben (Pseud.), 'The Percy Anecdotes' (Printed for T.Boys 1820–1823).
17 Letter from Josiah Wedgwood to Dr Erasmus Darwin, 15 April 1765. Wedgwood letters, Vol I, 56 (microfilm).
18 Memorandum of an Agreement between Randle Wilbraham of Rode Hall, Esq. and John Sparrow of Newcastle-under-Lyme, Staffs, Gentleman, on behalf of the Company of Proprietors of the Navigation from the Trent to the Mersey, dated 24 June 1768. Cheshire and Chester Archives and Local Studies Service, DBW/L/L/A/2.
19 The letter reads: 'Sir, Inclosed you receive the Bill of what you sent for me to London. I must beg the favour of you to send just the same to John Brooke Esq at Hall Wood nr Warrington with an addition of two more Quart Jugs & I will take care to discharge the debt.... From Yr most humble Servt, John Antrobus, Rode Hall, 30th Oct 1769, Do send the above as soon as you possibly can.' Wedgwood MS 31/23271.

Chapter 2

20 Richard Wilbraham graduated from St. John's, Oxford in 1742, thereafter attending Lincoln's Inn where he was called to the bar in 1747. Sedgwick, Romney 'The History of Parliament, The House of Commons 1715–1754. II Members E-Y', p. 639 (Her Majesty's Stationery Office 1970).

21 Mary Bootle's later portrait was painted by the Liverpool artist, Thomas Allen. The Wilbraham Household Account Book records a payment of 25 guineas in 1804.

22 George Romney's reputation as a portrait painter was rivalled only by Sir Joshua Reynolds in the eighteenth century. He painted a number of portraits of the Wilbraham Bootles which are included in Cross, David A. 'A Striking Likeness, the Life of George Romney'. (Bathgate, 2000) His portrait of Mary Bootle as a young woman, painted in c.1765 is now in a private collection whilst that of her in middle age is in the possession of Scotland's National Gallery in Edinburgh (NG 1674) with the information that his diary recorded six sittings between March and April of 1781. That portrait was purchased from an auction of Early English Portraits held by Christie, Manson & Woods on 17 July 1925; it was sold as the property of the Right Hon. The Earl of Lathom (National Art Library, Victoria & Albert Museum, 23xx). Romney's painting of 'Masters Edward Wilbraham Bootle and His Brother, Randle, When Boys', now in a private collection in England, was sold at the same time. A 1781 companion portrait of Richard Wilbraham Bootle, of which a copy hangs at Rode, is held by Wadsworth Atheneum in Hartford, Connecticut, USA.

23 Letter from Mary Wilbraham Bootle to Dr John Loveday, 27 April 1789.

24 John Loveday lived at Caversham and later Williamscote House near Banbury in Oxfordshire. Until 1777 he practised law, having gained a doctorate in Civil Law at Magdalen College, Oxford. His first interest was antiquary and in his youth he compiled the indexes to Chandler's edition of the Marmora Oxoniensia (1763) a catalogue of classical inscriptions and sculptures at Oxford. In his retirement he devoted his time to further scholarship and research. Like his father, also John Loveday (1711–1789), a philologist and antiquary, he contributed many articles to the Gentleman's Magazine. The libraries of both men are held at Penn State University in America. Copies of his correspondence with Mrs Bootle are held at Rode Hall.

25 Namier, Sir Lewis, and Brooke, John, 'The History of Parliament, The House of Commons 1754–1790. III Members K-Y', pp . 637–39 (Her Majesty's Stationery Office 1964).

26 Burton, E. 'The Georgians at Home 1714–1830', p. 60 (Longmans 1967). Reference to a letter written by Henry Pelham to the Duke of Devonshire in 1739.

27 Richard's first son, Edward Wilbraham Bootle, afterwards Bootle Wilbraham, gave this information to Lord Liverpool when canvassing for his own peerage in 1814. Thorne, R.G. 'The History of Parliament, The House of Commons 1790–1820. V Members Q-Y', p. 575 (Her Majesty's Stationery Office 1964).

28 Anne Dorothea (d.1825) married Richard, 1st Lord Alvanley; Mary (d.1784) married William Egerton of Tatton Park; Francisca Alicia (d.1810) married Anthony Hardolph Eyre of Grove, Nottinghamshire; Sibylla Georgiana (d.1799) married William Ffarington of Worden; Emma (d.1797) married Sir Charles Edmonstone, 2nd Bart of Duntreath; and Elizabeth (d.1741) married, after Mary Bootle's death, W. Barnes, rector of Brixton Doverill.

29 A Derby porcelain dinner service was sold to the Pepper Ardens for 18 guineas in 1788. An example of the service, decorated with a central group fruit and plain gold edge, was included in John Twitchett's 'Exhibition of Derby Porcelain' (1973). Ledger, A. P., 'An Important Derby Service decorated with flowers by William Billingsley, Commissioned by Mrs Bootle 1787–88' (Working Papers, October 2000).

30 Helen Maria Williams (1762–87) was a poet, novelist and letter writer. The volumes of poetry to which Mrs Bootle subscribed were published in 1786 whilst the following year she was herself the subject of a poem by William Wordsworth, 'On Seeing Miss Helen Maria Williams Weep at a Tale of Distress'.

31 Royal Society Library and Archives, Certificate of Election and Candidature (EC/1760/23)

32 Letter from Josiah Wedgwood to Thomas Bentley, 10 August 1771. Wedgwood MS W/M 1441.

33 Reilly, Robin, 'Wedgwood', Volume II, Appendix K, Busts 1774–1967 (Macmillan 1989).

34 Letter from Josiah Wedgwood to Thomas Bentley, 30 July 1773. Wedgwood MS 25/18484.

35 First son of Robert Bootle of Maghull, Lancashire, Sir Thomas was educated at Lincoln's Inn and called to the Bar at the Inns of Temple in 1713. He served as King's attorney and serjeant within the Duchy of Lancaster from 1712–1727 and attorney-general of the county palatine of Durham from 1733–1753. He was knighted on 23 November 1745. For further information, see Sedgwick, Romney 'The History of Parliament, The House of Commons 1715–1754. I Members A-D'. (Her Majesty's Stationery Office 1970) pp. 473–74.

36 Liverpool Record Office, Liverpool Libraries and Information Services. Entwistle Collection (942 ENT/1, f11).

37 The punch bowl remained in the possession of the Bootle family at Lathom Hall until 13 December 1920 when it was sold through Frank Stoner of London for £280. It was acquired by Dr Glaisher and was amongst his collection bequeathed to the Fitzwilliam Museum in Cambridge.

38 Poole, Julia E. 'English Pottery' pp. 48–49 (Fitzwilliam Museum Handbooks, Cambridge University Press 1995).

39 Memo to the 'Commander of the London', dated 18 December 1734. East India Office, British Library. (E/3/106, f132)

40 East India Office, British Library. (OIOC: G/12/38; OIOC: G/12/44)

41 These sums were calculated by David S. Howard. Howard, D. S. 'The Choice of the Private Trader, The Private Market in Chinese Export Porcelain Illustrated from the Hodroff Collection'. p. 20 (Zwemmer 1994).

42 Royal Society Library and Archives, Certificate of Election and Candidature (EC/1757/16).

42 Coincidentally, a blue and white service of c.1730 commissioned by the Lethieullier family also features parrots. Mary Bootle shared ancestry with the Lethieulliers, though this was through the distaff side.

44 Details of Mrs Bootle's purchases of Derby porcelain are recorded in summary annual sales tables (1783–85); in Day Book records (December 1786–May 1789); and in the Lygo/ Duesbury II letters (January 1787–June 1789) in The Duesbury Papers held in Derby Studies Library. They were first researched by the Derby porcelain scholar Andrew Ledger and, at the request of Sir Richard Baker Wilbraham, his extracts were included in an article written by John Twitchett, 'Billingsley at Rode Hall' (*Antique Dealer and Collectors Guide*, November 1998). Ledger's research was subsequently included in his own unpublished paper prepared for Sir Richard in 2000: 'An Important Derby Service decorated with flowers by William Billingsley, Commissioned by Mrs Bootle 1787–88' (Working Papers, October 2000).

45 Will of Ann Bootle, 13 February 1767. The National Archives, Public Record Office (Prob.11/939).

46 Wilbraham Family Papers, Cheshire and Chester Archives and Local Studies Service (DBW/N/D/61).

47 In a rare letter to Dr Loveday Senior, Mrs Bootle wrote: 'I have been endeavouring to get a Look at this Young Monarch who is now flying about, but in vain; his Motions are so Rapid & his mind Changes so Often that I have been twice disappointed in my designs to see him att Ranelagh.' Letter from Mary Wilbraham Bootle to Dr John Loveday Snr, 13 September 1768.

48 Baird, Rosemary, 'The Queen of the Bluestockings: Mrs Montagu's house at 23 Hill Street rediscovered' (*Apollo Magazine* 2003). du Bocage, Madame, 'Receuil des Oeuvres de Madame du Bocage', Vol. III Lettres sur l'Angleterre, p. 12 (Lyon 1762).

49 Letter from Mary Wilbraham Bootle to Dr John Loveday, 6 June 1799. Mrs Bootle enclosed in the letter a newspaper report of 'Mrs Wilbraham

Bootle's Speech on Presenting the Colours to the Ormskirk Volunteers' together with 'Major Hill's Reply'.
50 Will of Robert Bootle, proved 12th May 1758. The National Archives, Public Record Office (Prob. 11/837).
51 This service was the subject of an article written by John Twitchett, 'Old Japan' Discovered' (*Antique Dealer and Collectors Guide*, March 2000). Further information was included in a paper written by Julie McKeown in 2005: 'Derby' Old Japan' at Rode – further documentation and detail' (Derby Porcelain International Society, Newsletter No 57, Winter 2005/6)
52 The Red Book for Lathom's landscape garden and deer park was supplied by Repton in 1792. It was auctioned, as Lot 115, Sale No. 238, on 22 March 1927 by Harrods Auction Galleries, as part of a three day sale of the property of the Rt. Hon. The Earl of Lathom (National Art Library, Victoria & Albert Museum, Auction Catalogue 23.L). In 2004, the Red Book was auctioned by Sotheby's, New York, and purchased by Lancashire Record Office with National Art Fund assistance for £53,571. The Lathom House book includes two partially hand-coloured plans and four water colours. Three of the watercolours have the characteristic overlays by Repton.
53 Letter from Mary Wilbraham Bootle to Dr John Loveday, 6 February 1798.
54 Firn, Dilys, 'William Gould: an 18th century gardener' (*Lancashire Local Historian*, No. 17, 2004).
55 At the request of Andrew Ledger, plant art historian Dr Celia Fisher , formerly of the Royal Botanic Gardens, Kew, identified the plants depicted on the twelve Chelsea Brown Anchor plates. Her list is included in Ledger, A P L, 'An Important Derby Service decorated with flowers by William Billingsley, Commissioned by Mrs Bootle 1787–88' (Working Papers, October 2000).
56 In his memoirs Ehret mentions only a few of his pupils, all titled. Ehret, G.D. 'A memoir of Georg Dionysius Ehret... written by himself, and translated, with notes by E.S. Barton' (Proceedings of the Linnean Society of London 1894–95) (NAL. 188G.).
57 The Duesbury Papers, Derby Local Studies Library. DL82 1/180.
58 Keys left several different versions of his memoirs. This extract was included in a now lost draft which was transcribed by Wallis, A. and Bemrose, W. 'The Pottery & Porcelain of Derbyshire', pp. 11–13 (1870).
59 The attribution of Rode's Derby dessert service was made by Derby specialist John Twitchett in the late 1990s. In his article, 'Billingsley at Rode Hall' (Antique Dealer and Collectors Guide, November 1998), he described the service as 'possibly the major discovery of my long career as a ceramic historian'. (See also his 'Derby Porcelain 1748-1848, An Illustrated Guide', 'Rode' p26, Antique Collectors Club 2002.) Research by Andrew Ledger (See Footnote 25) identified Mrs Bootle as the commissioner of the service. This information and details of her other purchases were included in John Twitchett's article. Ledger subsequently wrote up his findings for Sir Richard as 'An Important Derby Service decorated with flowers by William Billingsley, Commissioned by Mrs Bootle 1787–88' (Working Papers, October 2000). This comprehensive unpublished paper discusses 'Some Unusual Derby Plates' by A L Thorpe (Antique Collector, July-August 1965), an article which suggested that the Derby plates made 'to match a Chelsea plate' might be four so-called 'Klepser' plates then owned by an American collector of that name. The Billingsley-decorated plates are similar in style to those at Rode but have turquoise enamel to their feather-edged rims in addition to brown. They are now dispersed in private and public collections, one being held by the Derby Museum & Art Gallery. A fifth plate owned by the 'late Major Dawney' is illustrated in John Twitchett's Derby Porcelain books. Andrew Ledger subsequently identified a record of a sale in 1787 to Lord Hawke of plates 'enam'd with different plates &c to match' which might also possibly relate to the order Keys described.
60 Ledger, A.P. ,'Derby Botanical Dessert Services 1791–1811, A Research Study' (Derby Porcelain International Society, Journal II 1991)
61 Plants depicted on the Billingsley service have been identified by plant art historian Dr Celia Fisher, formerly of the Royal Botanic Gardens, Kew, and are included in Ledger, A.P.L., 'An Important Derby Service decorated with flowers by William Billingsley, Commissioned by Mrs Bootle 1787-88' (Working Papers, October 2000)
62 Research by Andrew Ledger in 2005 found that in August 1789 Derby sold two similar seven-scolloped shaped bowls to Lord Viscount Cremorne as part of his large armorial dinner service of 1789. The item was listed as a 'salet dish'.
63 The Bowes Museum describes the bowls (X4459/1 and X4459/2) as 'wine glass coolers'.

CHAPTER 3
64 Randle Wilbraham's letters to Mrs Bootle written during his Grand Tour, 1793 to 1797. Wilbraham Family Papers. Cheshire and Chester Archives, Cheshire Record Office.
65 Byron wrote to his mother on 22 June 1809: 'I have a German servant, (who has been with Mr. Wilbraham in Persia before, and was strongly recommended to me by Dr. Butler of Harrow)... ' Marchand, Leslie A. ed. 'Byron's Letters and Journals, Volume 1, In My Hot Youth, 1798–1810' (Harvard University Press 1973).
66 An Account Book showing payments made by his parents to Randle Wilbraham 1788–1800.
67 Randle Wilbraham married Letitia Rudd on 5 December 1798 at the church of St Mary Le Bow, in Durham.
68 Although Pevsner suggests Rode's stable block dates from the 1750s, it is probable that it is of earlier construction as the London clockmaker responsible for its clock had gone out of business by 1730. Randle Wilbraham's General Account Book of 1799-1813 shows a payment was made on 14 February 1804 to 'Riley... for new stables etc £53 5s 2d' suggesting alterations continued to be made.
69 Baker Wilbraham, Bart. BA. FRICS. Sir Randle, 'Dobbs's Chapel, Some Notes On Its Origin & History' (1973).
70 Repton. H. Landscape Gardening & Accompts of my Time Employed 1788–90. Norfolk Record Office MS10.
71 The Wedgwood archive includes correspondence relating to purchases made by 'Mrs Laetitia Rudd, Haughton Durham' between 1774–1791. An earlier order for 'W Rudd' is dated 1769.
72 Cheshire and Chester Archives, Cheshire Record Office DBW/N/D/74.
73 The date usually given for Mortlock advertising itself as 'Manufacturers of Colebrook Dale Porcelain' is 1803. Messenger, M., 'Coalport 1795-1926', pp. 100, 413 (Antique Collectors' Club 1995).
74 This suggestion was made by Gaye Blake Roberts, Director, The Wedgwood Museum Trust.
75 Godden, G.A., 'Coalport and Colebrookdale Porcelains', p. 39 (Antique Collectors Club 1981).
76 See Messenger, M., 'Coalport 1795–1926', p. 170, plate 116, for an illustration of a similar service (Antique Collectors' Club 1995).
77 A 'Barbeaux Sprig Desert Sett... £5 5s 0d' appears on Spode's invoice of 1796 to 'W Tatton Esq', known as William Egerton to the Bootle and Wilbraham families.
78 A payment of £57 3s 2?d made in 1812 to 'Francey Marble Mason', probably Franceys of Liverpool, could relate to the supply of marble for this or another fireplace. Franceys also supplied porcelain and marble portrait busts.
79 Wedgwood MS 124/24133.
80 Cheshire and Chester Archives, Cheshire Record Office. DBW/N/D/87.
81 An invoice for Philip Egerton's purchases from Duesbury & Co in 1772–1773 is recorded in J. Haslem's 'The Old Derby China Factory, the Workmen and their Productions', pp. 20–21 (George Bell & Sons 1876). Amongst the goods he purchased for a total of £61 2s 6d were several Derby figures and a 44-piece dessert service with a border of 'medallions of cameo busts of Roman Emperors, in white on chocolate ground, connected by festoons'.

At the time Haslem was writing, the service was in the possession of Sir Philip de Malpas Grey Egerton, 10th Bart. A plate from the service is in the collection of the Victoria & Albert Museum in London and is illustrated in Snodin, M. and Styles, J. 'Design and the Decorative Arts, Britain 1500-1900', p. 267 (V&A Publications 2001).

82 Pattern 383, partly printed, partly hand-painted and using less gold, was more affordable for a wider market. It was also available on a Crown Earthenware body (as well as bone china) until the early 1900s. A new version, renamed 'King's Pattern', was produced from the early 1970s–90s. The design was then re-launched, with the new name 'Derby Japan', to coincide with Royal Crown Derby's 250th Anniversary in 1998.

83 This service was the subject of an article written by John Twitchett, 'Old Japan' Discovered' (Antique Dealer and Collectors Guide, March 2000). Further information was included in a paper written by Julie McKeown in 2005: 'Derby' Old Japan' at Rode – further documentation and detail' (Derby Porcelain International Society, Newsletter No 57, Winter 2005/6).

Chapter 4

84 Pearson, L., 'Minton Tiles in the Churches of Staffordshire'. (A Report for the Tiles and Architectural Ceramics Society, 2000), Appendix 2, The Minton Donation List.)

85 A letter written by Thomas Treloar of Ludgate Hill, 1864. Wilbraham Family Papers, Cheshire and Chester Archives and Local Studies Service.

86 Two replicas of 'Bluebeard and Gloriana' were commissioned following the picture's first showing at the Dudley Gallery in Piccadilly. The version now at Rode, dated 1871, was shown in the Tate Britain exhibition 'Pre-Raphaelite Vision: Truth to Nature' in Spring 2004.

87 The collection of Sibella Wilbraham's shawls was the subject of a small exhibition held at Rode in February 2004 in support of Macclesfield Silk Museums. 'The Raj to Rode, Sibella's Shawls' was curated by Annabel Wills, Museums' Conservator, and also showed at the Silk Museum in Macclesfield during 2005.

88 Examples of Rode's embroidered costume, then in the ownership of Sir Philip Baker Wilbraham 6th Bt., were featured in an article in *The Connoisseur* in January 1936.

89 A receipt, dated 1827, for 'a fine 8-leaf Japan screen bt by Mr Egerton from E H Pardock £41 0s 0d' is amongst family papers at Rode.

90 All items featured allegorical figurative subject matter. The four pairs of vases were entitled 'The Seasons' and 'The Hours'; 'The Ages of Man' and 'The Employments'; 'Knowledge' and 'Imagination'; and 'Science & Poetry' and 'Beauty & Utility'. The three trays were 'L'Allegro; Il Pensero, and 'Gannymed' [sic]); and the two single vases 'The Ten Virgins' and 'Painting & Music'.

91 Mrs Wilbraham Bootle's design for Wedgwood was possibly shape 901 described in a Wedgwood Majolica Pattern Book as 'Puck Tray'.

92 Correspondence regarding Mrs Bootle Wilbraham's designs for Minton and Wedgwood is held in the Wedgwood archive.

93 Correspondence from Sibella Wilbraham to Godfrey Wedgwood, November 1870, with sketch by Walter Crane. Wedgwood MSS 10/8094; 31/23891.

94 Shapes 992 and 1008 are both described in a Wedgwood Majolica Pattern Book as a 'Grape Stand for Dessert'.

95 Original sketches for Crane's design of tiles and vases for Maw & Co now form part of the Walter Crane archive which was acquired in 2003, with major grants from the Heritage Lottery and National Art Collections Funds, by the Whitworth Art Gallery and the Rylands Library in Manchester.

96 From that time, Crane became increasingly involved in art theory and education, with positions including Director of Design at Manchester's School of Art and from 1897-8 Principal of the Royal College of Art. When not travelling widely, he continued to paint and illustrate (producing cartoons and banners for socialist causes) and to undertake decorative art commissions. His only subsequent ceramic design was the work he produced for Pilkington's Lancastrian between c. 1896 and 1906. This comprised two tubelined tile panels, 'Flora's Train' and 'The Senses', both featuring Mucha-like figurative subjects, followed by a series of designs combining mythical and classical subjects, lustre glazes and lettering (a particular interest) on finely potted, simple shapes. Reproductions were made, usually painted by Richard Joyce, until the pottery department's closure in 1938.

97 The author first wrote on Walter Crane's connections to Rode Hall in 'Peacocks and Pottery: Walter Crane at Rode' (Antique Collecting, October 2004).

98 Correspondence, papers and diaries of General Sir Richard Wilbraham KCB for the period c.1845–94 are held in Cheshire and Chester Archives and Local Studies.

99 Frances M Wilbraham's essay, 'Recollections of Hursley Vicarage', was included in 'Musings over The Christian Year and Lyra Innocentium together with a few Gleanings of Recollections of the Rev. John Keble, gathered by several friends' by Charlotte Yonge (D Appleton & Co., New York 1871).

Chapter 5

100 McConaghey, R.M.S., 'Sir George Baker and the Devonshire Colic' (*Journal of Medical History*, October 1967).

101 Baker, George, 'An Examination of Several Means, by which the poison of Lead may be supposed to gain admittance into the Human Body, unobserved and unsuspected' (Medical Transactions of the College of Physicians 1768).

102 Percival, Thomas, DM, FRS, FRSA, 'Observations and Experiments on the Poison of Lead' (1774).

103 The Diaries of George Baker, later Sir George Baker Wilbraham, 1866–1912. Cheshire and Chester Archives and Local Studies (DBW 3667).

104 Will of Maria Charlotte Cooper, Public Record Office, The National Archives (Prob 11/1957). Maria shared with her father, physician Sir George Baker, a love of poetry and much of her juvenilia, including verses entitled 'Occasional Rhymes or Family Salt', are preserved amongst the Baker family papers at Rode.

105 The two Spode tureens each bear the pattern number 1202. The pattern is illustrated in a Spode factory pattern book on a Gadroon shaped cup and saucer under the pattern numbers 4069 and 4073. Information courtesy of The Spode Museum Trust.

106. Bennett, Arnold, 'Clayhanger' 'See this, my boy?' said Tom, handing to Charlie a calf-bound volume, with a crest on the sides. 'Six volumes. Picked them up at Stafford—Assizes, you know. It's the Wilbraham crest. I never knew they'd been selling their library.' Charlie accepted the book with respect. Its edges were gilt, and the paper thin and soft. Edwin looked over his shoulder, and saw the title-page of Victor Hugo's 'Notre-Dame de Paris,' in French. The volume had a most romantic,

foreign, even exotic air. Edwin desired it fervently, or something that might rank equal with it.'

107 'Cheshire At War 1914–1918', Chester Armistice Week, 4–11 November (Cheshire County Council 1978).

108 'Sir Philip Wilbraham Baker Wilbraham, 6th Bt. Brown, James and Pottle, Mark' (*Oxford Dictionary of National Biography* 2004).

109 What are believed to be the only surviving family and estate records are held at Lancashire Record Office. They are thought to have been deposited with estate solicitors in London in 1946 as part of the Earl of Derby's papers (Bootle-Wilbraham of Lathom DDLM).

110 Information on Ned Lathom and Lathom Hall has been compiled by the Lathom Park Trust, Silcock House, Hall Lane, Lathom, Ormskirk, Lancashire, L40 5UJG.

111. Correspondence dated 1962–66 relating to James Russell's work at Rode is held in the James Russell Archive, the Borthwick Institute of Historical Research, York University. (??/1/29).

112. See Chapter Two, page 63.

Credits

All photographs of the Rode Collection copyright Jeremy Phillips, excepting those on pages 30, 98, 99, 104, 112, 114 and Fig.123 on page 130 which are courtesy of Northern Counties Photographers and Fig.110, Page 111 by kind permission of Richard Dennis.

Other illustrations are reproduced by courtesy of:

Fig.19, Page 28	The National Gallery of Scotland
Fig.26, Page 37	The Fitzwilliam Museum, Cambridge
Fig.28, Page 40	The British Library
Fig.75, Page 77	The Bowes Museum, Barnard Castle
Fig.105, Page 108	The Trustees of the Wedgwood Museum, Barlaston, Staffordshire
Fig.106, Page 108	The Trustees of the Wedgwood Museum, Barlaston, Staffordshire
Fig.108, Page 110	The Trustees of the Wedgwood Museum, Barlaston, Staffordshire

Dessert table layouts on pages 72 and 76 courtesy of Peter Brown, Fairfax House, York.

Quotations from the Wedgwood archive by kind permission of the Trustees of the Wedgwood Museum, Barlaston, Staffordshire.

Quotations from the correspondence of Mary Bootle to Dr John Loveday, held in the Loveday archive, by kind permission of Francis Markham.

Acknowledgements

FIRSTLY I WOULD LIKE to thank Sir Richard Baker Wilbraham for offering me the opportunity to research and write the story of Rode Hall and its porcelain. Sincere thanks to him and Lady Baker Wilbraham for their constant support, encouragement and kindness. Acknowledgements are, of course, due to numerous ceramics specialists who have assisted and informed Sir Richard over the years but in the writing of this book I am especially indebted to Andrew Ledger for allowing me to draw on and discuss with him his research on the Derby 'Billingsley' service; and to the late David Sanctuary Howard for his invaluable help on Chinese armorial porcelain. Grateful thanks also to the custodians of the papers of the late Sarah Markham for allowing me to quote from the correspondence of Mary Bootle to Dr John Loveday. Especially instructive has been the expert advice of Peter Brown, Fairfax House, York; Gaye Blake Roberts, the Wedgwood Museum; Richard Dennis; Colin Hanley; Stephen Hanscombe; David Kitson; and Rodney Woolley, Christie's. Special thanks to Jeremy Phillips who travelled to Rode, in fair weather and foul, to photograph the ceramics collection.

Thanks also to Anneke Bambery and Sarah Allard, City of Derby Museum and Art Gallery; Maureen Batkin; Jill Banks, Kedleston Hall, Derbyshire; Peter Boyd, Shrewsbury Museum and Art Gallery; Helen Burton, Special Collections and Archives, Keele University; Wendy Cook, Worcester Porcelain Museum; Lucy Clemson; Roger Edmundsen; Mark Fletcher; Rebecca Fortey, Tate Publishing; Dr. J.R. Freeman; Elizabeth Gabay; Sharon Gater and Lynne Miller of the Wedgwood Museum Trust; Angela Howard; John R. Hodgson, John Rylands University Library of Manchester; Alex Kidson, Walker Art Gallery, Liverpool; Joan Jones and Les Smith, Minton Museum; Barry Lamb, Reference Works; Margaret Makepeace, India Office Records, the British Library; Lynda McLeod, Christie's Archives; Malcolm Nixon; Andrew Peppitt, the Devonshire Collection, Chatsworth; Murray Pollinger; John Powell, Ironbridge Gorge Museum Library and Archives; Julia Poole, The Fitzwilliam Museum, Cambridge; Jennie Rathbun, Houghton Library, Harvard University; Caroline Schofield, Tatton Park; Alistair Smith and Charles Nugent, The Whitworth Art Gallery, Manchester; Jacqueline Smith, Royal Crown Derby Museum; Mari Takayanagi, The Parliamentary Archives, House of Lords Record Office; Jennifer Thompson, Coalport Museum; John Twitchett; Gareth Walker, Northern Counties Photographers; Karin Walton, Bristol Museums & Art Gallery; Pam Woolliscroft, the Spode Museum Trust; members of Lathom Park Trust; and archivists at Cheshire and Lancashire County Record Offices.

And very grateful thanks for the encouragement of my family and friends.

Select Bibliography

Adams, E., *Chelsea Porcelain* (British Museum Press, 2002)

Aslet, C., 'Rode Hall, Cheshire, The Seat of Sir Richard Baker Wilbraham' (*Country Life*, May 1985)

Baker Wilbraham Bt., Sir R., *Dobb's Chapel, Some Notes on its Origin & History* (1973)

Bateman, B., *All Saint's Odd Rode, The History of the Church 1864–1989* (Odd Rode Parochial Church Council 1990)

Batkin, M., *Wedgwood Ceramics 1846–1959* (Richard Dennis 1982)

Bressey, S. and Pollinger, M. *Porcelains of the Ralph Stevenson & Samuel Alcock Partnerships 1822-1831*, The Northern Ceramic Society Journal, Volume 20, 2003–04)

Copeland, R., *Spode & Copeland Marks And Other Relevant Intelligence* (Studio Vista 1993, 1997)

Cartlidge, Rev. J.E.G., *Newbold Astbury and Its History* (Old Vicarage Publications, Congleton 1985)

Crane, W. *An Artist's Reminiscences* (Methuen 1907)

Day, I., Ed., *Eat, Drink & Be Merry, The British at Table 1600–2000* (Philip Wilson Publishers Ltd 2000)

Ehret, G.D. 'A memoir of Georg Dionysius Ehret... written by himself, and translated, with notes by E.S. Barton' (Proceedings of the Linnean Society of London 1894–95)

Emmerson, R., 'British Teapots & Tea Drinking 1700–1850' (HMSO 1992)

Farrington, A., *Trading Places, The East India Company and Asia 1600–1834*. (The British Library 2002)

Girouard, M., *Life in the English Country House* (Yale University Press 1978)

Gore, Ann and Carter, George, ed., 'Humphry Repton's Memoirs' (Michael Russell Publishing Ltd 2005)

Hanscombe, S., *James Giles, China and Glass Painter (1718–80)* (Stockspring Antiques exhibition catalogue, 2005)

Howard, D.S., *A Tale of Three Cities, Canton, Shanghai & Hong Kong, Three Centuries of Sino-British Trade in the Decorative Arts* (Sotheby's 1997)

Howard, D. S., *The Choice of the Private Trader, The Private Market in Chinese Export Porcelain Illustrated from the Hodroff Collection* Zwemmer 1994)

Howard, D. S., *Chinese Armorial Porcelain*, Volume I (Faber & Faber 1974); Volume II (Heirloom and Howard 2003)

Lake, J., *The Great Fire of Nantwich* (Shiva Publishing Limited 1983)

Ledger, A.P., 'Derby Botanical Dessert Services 1791–1811, A Research Study' (*Derby Porcelain International Society*, Journal II, 1991)

Ledger, A.P., *An Important Derby Service decorated with flowers by William Billingsley, Commissioned by Mrs Bootle 1787-8* (Working Papers, October 2000)

Messenger, M., *Coalport 1795–1926* (Antique Collectors' Club 1995)

Nightingale, J.E., *Contributions Towards the History of English Porcelain* (First published Salisbury 1881, EP Publishing Ltd 1973)

Poole, J.E., *English Pottery* (Fitzwilliam Museum Handbooks, Cambridge University Press 1995)

Pevsner, N. and Hubbard, E., *The Buildings of England, Cheshire* (Penguin, 1971)

Reynolds, D., *Worcester Porcelain* (Ashmolean Museum, Oxford 1999)
Richards, S., *Eighteenth Century Ceramics, Products for a Civilised Society* (Manchester University Press 1999)
Sandon, J., *The Illustrated Guide to Worcester Porcelain 1751–1793* (London 1980)
Snodin, M. and Styles, J., *Design & The Decorative Arts Britain 1500–1900* (V & A Publications 2001)
Spencer, I., *Walter Crane* (Studio Vista 1975)
Synge-Hutchinson, P., 'G D Ehret's Botanical Designs on Chelsea' (*Connoisseur*, October 1958)
Thorpe, A.L., 'Some Unusual Derby Plates' (*Antique Collector*, July–August 1965)
Twitchett, J., 'Billingsley at Rode Hall' (*Antique Dealer and Collectors Guide*, November 1998)
Twitchett, J., ''Old Japan' Discovered' (*Antique Dealer and Collectors Guide*, March 2000)
Twitchett, J., *Derby Porcelain 1748–1848, An Illustrated Guide* (Antique Collectors Club 2002)
Uglow, J., *A Little History of English Gardening* (Chatto & Windus 2004)
Vickery, A., *The Gentleman's Daughter, Women's Lives in Georgian England* (Yale University Press 2003)
Young, H., *English Porcelain 1745–95, Its Makers, Design, Marketing and Consumption* (V&A Publications 1999)

Index

Aagate ware 23
Alcock, Samuel & Co 76–77
All Saints' Church, Odd Rode 84, 99–101, 112, 113
Alvaney, Richard Pepper Arden, 1st Baron 32
Alvaney, William Arden, 2nd Baron 32
Anstice, Horton & Rose 88
Antrobus, John 27
Arden, Miss C F. 100
armorial porcelain 43–48, 133

Bailey, John 103
Baker, Sir George, 1st Bt. 115–17, 128
Baker Wilbraham, Lady Anne 112, 123, 127, 128, 129, 132
Baker Wilbraham, Lady Betty 125–26, 127
Baker Wilbraham, Sir George Barrington, 5th Bt. 113, 115
Baker Wilbraham, Lady Katharine 93–94, 100, 101, 113, 115, 119
Baker Wilbraham, Letitia 127
Baker Wilbraham, Sir Philip, 6th Bt. 121–22, 123–24, 124, 128
Baker Wilbraham, Sir Randle, 7th Bt. 125, 126, 127, 129
Baker Wilbraham, Sir Richard, 8th Bt. 76, 108, 112, 115, 127, 128, 129
Barnard, Harry 123
bat-printing 91
Bateman, James 102
Bateman, Maria 102
Bateman, Robert 112
Beechey, Sir William 89
Bell, Samuel 25
Bennett, Arnold: *Clayhanger* 121
Bentley, Thomas 25
Bernasconi, Francis 93
Billingsley, William 71–72, 73–75, 95
Bishop & Stonier Ltd 119
blue-and-white china 14, 58, 91, 104
bone china 73
Bootle, Ann 41, 46, 48
Bootle, Mary *see* Wilbraham Bootle, Mary
Bootle, Matthew 42
Bootle, Captain Robert 29, 39–43, 43–44, 46, 48, 58, 71
Bootle, Sir Thomas 29, 36, 39, 43–44, 45, 123
punchbowl 37–38, 123
Bootle Wilbraham, Ada Constance 102–3
Bootle Wilbraham, Edward *see* Skelmersdale, 1st Baron
Bootle Wilbraham, the Hon. Mrs Jesse 109
Boreman, Zachariah 72, 75
botanical wares 68–78, 132
Bott, T J 35, 117
Böttger, Johann Frederich 15
bough-pots 94–95
Bow 21, 22, 57–58, 65–66, 69, 134
Braddell, Darcy 124–25
Bridgeman, Charles 18
Bristol 13, 54
Brooks, John 21
Broughton, Lady Elizabeth 93
Brown, Lancelot 'Capability' 19
bulb-pots 94–95
Burke, Edmund 34
Byerley, Thomas 91

'cabinet cups' 50
Caldecott, Randolph 112
Campbell, Mrs Patrick 123
Carey, J & W 92
Catherine II, Empress 69
'caudle cups' 50
Chaffers, Richard 38
Chapel of the Holy Trinity, Scholar Green 84
Charlotte, Queen 25
Cheere, John 36
Chelsea 21, 22, 46–47, 50, 58, 59–60, 60, 65–66, 134
'Hans Sloane' plates 68–71, 89
Chinese porcelain 14, 22, 39, 41, 42, 43–46, 48–49, 56, 91, 133
Chippendale, Thomas 35
chocolate cups 49–50
Christian, Philip 38
Christie's 59, 88, 119
Coalport 86–89, 117, 120–21
Cobb, John 93
coffee services 49
Coleman, Enrico 108
Cookworthy, William 20, 116–17

Cooper, Gladys 123
Cooper, Sir John Hutton 120–21
Cooper, Maria Charlotte 120, 121
Copeland, W T & Sons 117
Costa, Emanuel da 43
Coward, Noel 122
Crane, Anthony 108
Crane, Thomas 104
Crane, Walter 103–12
creamware 23, 24–25
Curtis's *Botanical Magazine* 75, 85
Cutts, John 95

Damer, Mrs Anne Seymour 121
Darwin, Dr Erasmus 26–27, 34
Davenport manufactory 91
Defoe, Daniel 14
delftware 13, 37
Dennis, Richard 132
Derby 21, 22, 46–48, 51, 52–53, 59–60, 117, 134
'Billingsley' dessert service 71–76, 89, 134
'Old Japan' dinner service 95–97
dessert services 59–60, 60, 61–63, 67, 68–71, 69, 71–76, 71–77, 87–79, 89, 126, 134
'Devonshire Colic' 116
dinner services 43–46, 55–67, 95–97, 120–21
Dixon, Austin & Co 133
Doulton & Co 117
Duesbury & Co 47
Duesbury, William, I 46–47
Duesbury, William, II 76
Duvivier, William 60
Dwight, John 13–14, 53

East India Company 22, 39–43, 48, 91
Egerton, Mary 32
Egerton, Wilbraham 32
Egerton, William 32, 73
Ehret, Georg Dionysius 69, 70–71
Elers brothers 23, 53

felspar porcelain 89
Ffoulkes, Katharine 122
Flaxman, John Jnr 119
Fogelberg, Andrew 86
Frye, Thomas 58

George, Prince of Wales (later Prince Regent, George IV) 32, 33, 57, 73, 74, 83, 89–90, 91
George III 33, 115, 116
Gerard, John 18
Gilbert, Stephen 86
Giles, James/Giles atelier 22, 52, 60–61, 134
'Girl-in-a-Swing' porcelain 21
Goldsmith, Oliver 116
Goode, Thomas & Sons 119
Goodwin, Robin: 'Breakfast at Rode' 127–28
Gould, William 68–69
Gouyn, Charles 21
Gray, George 86
Gray, Thomas 116
Green, Guy 22
green glazed ware 23–24
Gregson & Buller 86
Gubbins, Lieutenant 107
Gubbins, Annie 107, 108

Hamilton, Lady Emma 82
Hamilton, Sir William 34–35, 82, 121
Hancock, Robert 22
hard-paste porcelain 20, 54
Harding, Ralph and John 17–18
Heath, Dick 105, 112
Heath, Mary 112
Hepple, Norman 112
Hiorne, David and William 17, 18
Hope, John 83–84
Houssaye, Isaac 40
Hudson, Thomas 17
Hume, David 34

Imari porcelains 58, 59, 96

James I 18
Japanese porcelain 22, 58–60
Johnson, Colonel Harry 124
Johnson, Dr Samuel 34
Joseph, Sir Francis 76

Kaendler, Charles Frederick 57
Kakiemon motifs 58–59
Keble, Rev. John 113
Kent, William 18
Keys, Samuel 71–72

'Ladies Amusement, The' 22
Lambeth delftware 13

Langlois, Pierre 93
Lathom, Edward Bootle Wilbraham, 3rd Earl ('Ned Lathom') 122–23
Lathom Hall 29, 36, 68–69, 78, 122–23
Lawlor, John 100
Lawrence, Gertrude 123
Legros, Alphonse 112
Leoni, Giacomo 29
Lessore, Emile 107
Limehouse 21
Linley, David 93
Liverpool 21, 22, 24, 36–39
Sir Thomas Bootle's punchbowl 37–38, 123
Longton Hall 21, 24, 66
Loveday, Dr John 30, 34, 55
Lowestoft 21
Lygo, Joseph 47, 71, 76

Makepeace, Robert 86
Makower, Sibella 132
Marot, Daniel 14
Mason, Miles 89
Maw & Co 110
Walter Crane vases 111–12, 134
Meissen 15, 22, 56, 60
Miller, Philip 70
Miller, Sanderson 18
Minton 100, 117
tiles 100, 110–11
'Wilbraham Tray' 100, 109
Minton, Herbert 100
Montagu, Lady Mary Wortley 30, 33
More, Hannah 34
Moreton, Richard 40
Morris, William 111
Mortlock, John & William 86, 87–88
Mow Cop Castle 18, 19, 123–24
Murrell, Hilda 126

Nesfield, William Andrew 103
Newnam, Richard 40
Nightingale, Florence 113
Novello, Ivor 123
nursery ware 127

Oakley, George 86
O'Connor, Arthur and Michael 101
O'Neale, Jefferyes Hamett 22, 134

Paine, Thomas 34
Palmer, Maria 116
Pardoe, Thomas 88
Parian ware 100
Pennington, James 38
Philip, J B 100
Pinxton works 74, 95
Plymouth 54
Pope, Alexander 18
porcelain 14–15, 20–21, 53–54
Portmeirion: 'Botanic Garden' 77–78
posset pots 13
Priest, Samuel 94
Pritchard, Thomas 20
Pugin, A W N 100

Raffald, Elizabeth 57
red stoneware 13, 23, 53
Reid, William 38–39
Repton, Humphry 18, 68, 84–85
Reynolds, Horton & Rose 86
Reynolds, Sir Joshua 116
Rode, Elizabeth 11–12
Rode, Randle 11–12
Rode Hall 15, 16–17, 20, 83–84, 85–86, 91–93, 101–2, 123–25, 128, 129–30, 134–35
gardens 18–19, 68, 84–85, 93–94, 102–4, 125–26, 130–31
ice house 19–20
Rogers, James 65
Rose, John 86, 89, 91, 121
Rose & Co 86, 88
Rose, Thomas 86, 87–88
Rouw, Peter, the Younger 85, 89
Royal Crown Derby 96, 117
Russell, James 126

Sadler, John 22
Sadler & Green 24, 36
salt-glazed stoneware 13, 14, 23
Scott, Sir Giles Gilbert 99–100, 101
Scrivener & Sons 124
Sèvres 22, 56–57
Skelmersdale, Edward Bootle Wilbraham, 1st Baron 32, 69, 78
slipware 13
snowdrops 103, 130, 132
Soane & Smith 119
soft-paste porcelain 20–21, 53
Spode 73, 89–91, 117, 121
Spode, Josiah, I 73

Spode, Josiah, II 90
Sprimont, Nicholas 21, 65
Staffordshire 13, 23, 54, 89, 117
Stephenson & Hancock 117
stone china 89
Sunderland ware 132–33

Tatem, Thomas 97
Tatton, William *see* Egerton, William
Tatton Park 32–33, 73
Taylor, Sir Robert 17
teapots 38, 52–55, 133–34
tewares 46–48, 48–55, 91
Tempest, Marie 123
Toft family 13
Tollemache, Beatrix 124
Tooke, Peter 81
tortoiseshell ware 23
Townsend House, Nantwich 11, 12, 15–16, 18
transfer-printing 21–22
Tuffin, Sally 132, 134
Turner, Thomas 91
Turner of Lane End 89

Vauxhall 21, 22
Vulliamy, Benjamin Lewis 92

Wall, Dr John 22, 63, 116, 117
Walpole, Horace 16
Warburton, Rowland Egerton 102
Webb, John 85
Wedgwood 91, 117
Black Basalt 25, 34, 35–36
cream ware 24–25, 36
garden pots 94
'Green Frog' dinner service 69
Jasper 25, 34, 119–20
Queen's Ware 25, 117
toilet sets 120
Walter Crane designs 109
Wedgwood, Godfrey 107, 109
Wedgwood, John 94
Wedgwood, Josiah 23–27, 34–36, 117, 134
Wedgwood, Josiah, II 91
Wedgwood, Richard 25
Wedgwood, Sarah 25
Whieldon, Thomas 23–24
Whitehead, William 32
Wilbraham, Alice 12
Wilbraham, Rev. Charles Philip 100, 112–13, 124
Wilbraham, Dorothy 16
Wilbraham, Frances Maria 113, 128
Wilbraham, Letitia 82–83, 85, 87, 89, 128
Wilbraham, Mary 15
Wilbraham, Randle, I 12, 13, 15–16
Wilbraham, Randle, II 16, 17, 25, 26–27, 128
Wilbraham, Randle, III 32, 73, 79, 81–83, 84, 85, 89–90, 91–92, 93, 96
Wilbraham, Randle, IV 99, 101, 105
Wilbraham, Richard 16, 18
Wilbraham, General Sir Richard 112–13, 119, 128
Wilbraham, Roger 11–13, 14, 15, 18, 128
Wilbraham, Sibella 99, 100, 101, 102–3, 105, 106, 107, 109–10, 128
Chattering Jack 105–6
Wilbraham, Sibylla 91–92, 93, 96
Wilbraham, Thomas 128
Wilbraham Bootle, Edward *see* Skelmersdale, 1st Baron
Wilbraham Bootle, Mary 27, 29–34, 41, 46–48, 48, 50, 51–52, 52, 55–56, 57, 60, 63, 68, 71, 75–76, 78–79, 81, 82–83, 84, 86–87, 89, 96–97, 116
Wilbraham Bootle, Randle *see* Wilbraham, Randle, III
Wilbraham Bootle, Richard 27, 29, 31, 32, 34, 59, 116
Wilde, Oscar 104, 111
Williams, Helen Maria 34
Wilson, Robert and David 86
Worcester 21, 22, 24, 50, 51–52, 53–54, 58, 60–61, 91, 117, 134
'Dr Wall' blue-scale dessert service 61–64, 126
Wyatt, Lewis 91–92

Yonge, Charlotte 113